MW00604953

THE BIG SKY BOUNTY COOKBOOK

LOCAL INGREDIENTS AND RUSTIC RECIPES

CHEF BARRIE BOULDS AND JEAN PETERSEN

- Enjoy -

Jean Petersen

- Come to the table -

AMERICAN PALATE

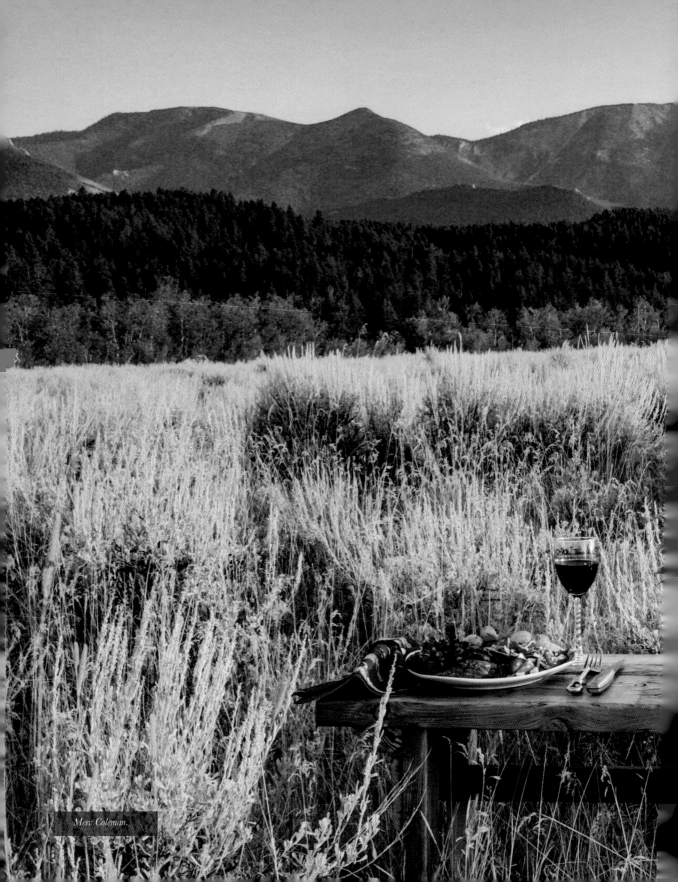

Merv Coleman.

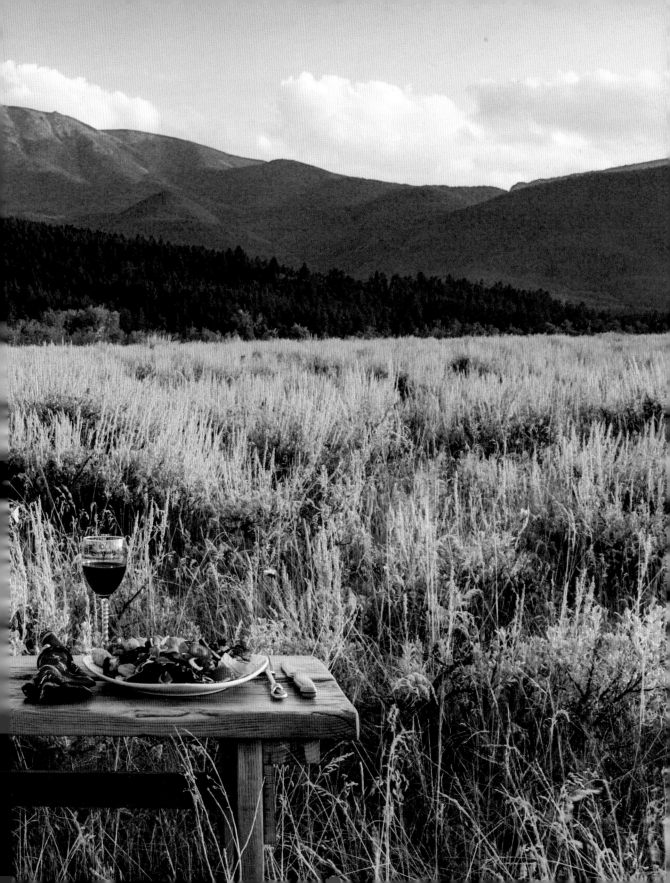

Published by American Palate

A Division of The History Press

Charleston, SC

www.historypress.com

Copyright © 2018

by Barrie Boulds and Jean Petersen

All rights reserved

First published 2018

Manufactured in the United States

ISBN 9781467138734

Library of Congress Control Number: 2018936070

Notice: The information in this book is true and complete to the best of our knowledge. It is offered without guarantee on the part of the authors or The History Press. The authors and The History Press disclaim all liability in connection with the use of this book.

All rights reserved. No part of this book may be reproduced or transmitted in any form whatsoever without prior written permission from the publisher except in the case of brief quotations embodied in critical articles and reviews.

Nicole O'Shea

This book is dedicated to my beautiful mom.
—BB

*With love, I dedicate this book to my devoted mom, Sharon,
and my dear stepmom, Betty.*
—JP

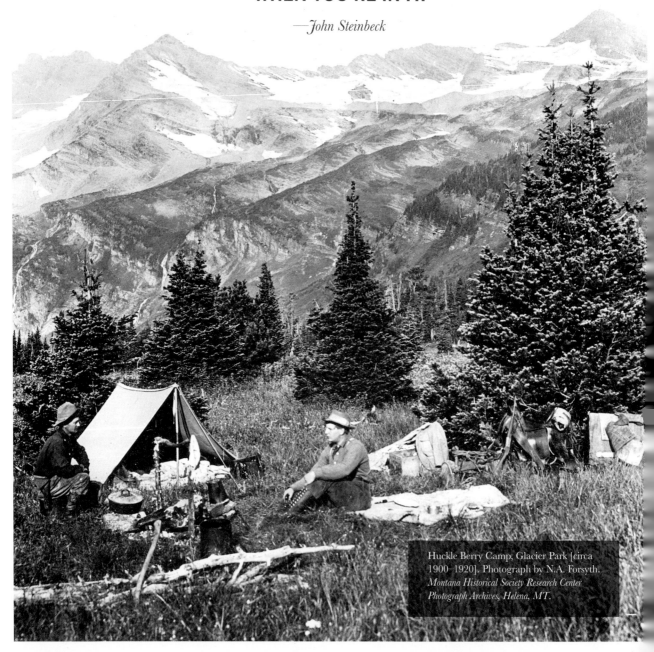

I'M IN LOVE WITH MONTANA.
FOR OTHER STATES I HAVE ADMIRATION,
RESPECT, RECOGNITION, EVEN SOME
AFFECTION. BUT WITH MONTANA IT IS LOVE.
AND IT'S DIFFICULT TO ANALYZE LOVE
WHEN YOU'RE IN IT.

—*John Steinbeck*

Huckle Berry Camp, Glacier Park [circa
1900–1920]. Photograph by N.A. Forsyth.
*Montana Historical Society Research Center
Photograph Archives, Helena, MT.*

CONTENTS

Dorvall Club lambs, Bromberg, Montana. *Holly Dorvall.*

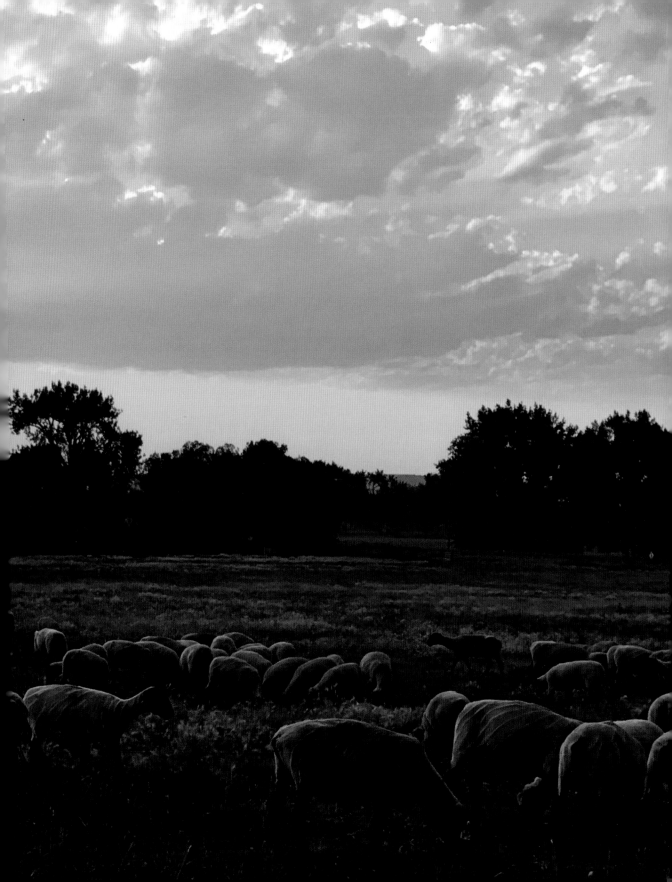

Jean Petersen

FOREWORD

Here in Montana, you can relish in the state's leading industry of agriculture, from the vast fields of wheat and grains to hobby pig farms. With our clear rivers, big skies and clean air, the food cultivated in Montana's fields and land has a layer of flavors rarely found elsewhere. I have been cooking meals professionally for more than twenty-five years, and still, nothing compares to the quality of lamb from Sweet Grass County or the fresh huckleberries picked along the mountain streams. Agriculture is a part of life for many Montanans. If you are fortunate enough to share in the practices of their hard work, the food you are savoring becomes a story more than a meal. Take a drive through Montana along the miles and miles of wheat fields or past the green spring pastures filled with newly born calves, and you can smile knowing that the quality of ingredients you receive in Montana is well nourished through the air, water and the hands that tend the land.

Journeying at farmers' markets throughout the state, you cherish a feeling you had as a child of going through a candy store. At these markets, you can purchase beef, goat, poultry, berries, fresh produce, honey, grains, freshly baked goods and more. You have recipes dancing through your head as you contemplate which ingredients you are going to prepare at home and which you are going to enjoy tasting on the ride home. At a farmers' market, you can share stories and recipes with friends of what they purchased last week, along with your plans for the upcoming week. I enjoy asking the farmer or rancher about their favorite use of their product or why they decided to grow a particular type of fruit or vegetable.

I have been invited to beef ranches where you recognize the sustainable practices they have developed to not only provide a better product but also to provide an

environment for their children's children to raise cattle. By supporting this agricultural community, we are not only gifted with a better product, but we are also supporting our farmers' and ranchers' livelihood. Montana also provides a hunter's paradise. We have great bird hunting in the prairies, big game in the mountains and freshwater fishing as good as you can find. Through food, we help bring families and communities together. Through this book, you can provide more shared stories and culture of Montana food.

Chef Barrie Boulds has utilized ingredients raised, harvested, grown, picked, hunted and fished throughout the hundreds of years in Montana, and she has prepared ingredients in ways that combine traditional and contemporary cooking techniques. Chef Boulds' inspirations come from techniques used around the world, including those from France, Asia, Italy, Spain and Native American traditions. From these inspirations, she creates recipes for you to enjoy throughout the seasons. Following these recipes, you can bring out the true flavors of Montana history and the quality of local ingredients.

—Chef Eric Trager

Executive chef of the Old Piney Dell located at Rock Creek Resort in Red Lodge, Montana, Eric Trager has twenty-five years of experience providing culinary masterpieces. He's the vice chair of the Chefs and Cooks of Montana and the organization's past president (2015 and 2016). Chef Trager is an active member of the Western Sustainability Exchange, promoting Montana-made products and sustainable products. He was honored as Chef of the Year in 2009 by the Chefs and Cooks of Montana and received gold and silver medals at the Montana Connection Chef's Competition in 2004 and 2005. Chef Trager is a graduate of the culinary program at Paul Smith's College in upstate New York.

FOREWORD

Since 1995, except for a three-year period from 2005 to 2008, I have been employed in a variety of editor positions of the weekly ag newspaper *Western Ag Reporter* and its predecessors, *Western Livestock Reporter* and *Agri-News*. Jean Petersen was hired as a freelance writer during my absence, and just six months prior to my return, she had created for the younger readers of the paper a wonderful weekly series about a three-legged working stock dog named Banjo and all his animal, bird and reptile friends that live and work on a Montana ranch. Because Jean submits her column via e-mail every week, it took me several years to actually meet her. But believe me, before that nice event happened, I knew the young woman well, as she writes what she knows—and what she knows is rural life well lived.

While performing the multitude of duties required to fulfill her roles as a busy multitasking ranch wife and mother of four, Jean extracted from the hectic life around her, teeming with not only any wife and mother's personal activities and misfortunes but also the weather-related events and tragedies as orchestrated by the capricious and all-powerful Mother Nature that all rural wives and mothers deal with on a daily basis, year in/year out—colorful, interesting and accurate details that she wove into the lives of her fictional ranch critters. One only has to read her most recent column to know the issues she was currently dealing with at home—both inside and out. Jean has a knack for getting to the heart of the matter—we call it "cutting to the chase" in our circles—and wrapping that up, along with a generous dose of humor and history.

The women who occupy my circle, which includes Jean, are principled, hardworking women who routinely take on more than their plates can hold…and complete one well-turned-out project after another. Like many of us, Jean has struggled to properly

utilize the wonderful selections of locally raised and processed meat that fill our freezers. Unlike the rest of us, Jean has found a wonderful method to solve not only her challenge but also the struggle of untold numbers of other busy women charged with feeding their families nutritious meals with limited time. In the process, she is part and parcel of presenting to cooks—young and old, novice and experienced, eastern and western—a unique collection of recipes illustrated and added to by marvelous bits and pieces of relevant history. To say that I'm proud of her for this banner project is to make an understatement of vast proportions. However proud, I am not in the least surprised. This is but the latest of Jean's worthwhile projects. Enjoy!

—LINDA GROSSKOPF
Editor, *Western Ag Reporter*
2008–2018

ACKNOWLEDGEMENTS

A very special thank you to the DeSarro family and Hope Ranch International (hoperanchinternational.org); Sager family; Tomlin family; Holdbrook family; Vezain family; Fouts family; Mains family; Neibauer family; King family; Reimer family; Fitzgerald family; Steve Palmer; Cole family; Ken and Cindy Swan; and Holly Dorvall of Dorvall Club Lambs in Fromberg, Montana, for the beautiful venues to capture many great photos. I am grateful for the bounty these families provided in the natural resources used to make these recipes and in creating the photo shoots, many of whom also assisted as my taste testers with numerous successes and a few impressive failures; I am truly grateful for everyone's support and encouragement. A heartfelt thank-you to Jenny McPhail for her professional editing and proofreading expertise, along with her faithful support of this book, to see it through to its full fruition. I am honored and especially grateful to Chef Eric Trager for providing a foreword. His expertise and ongoing involvement working with sustainable products and organizations across Montana are instrumental to these resources' long-term viability. I am additionally humbled, honored and filled with gratitude to *Western Ag Reporter* editor Linda Grosskopf, who also provided a foreword. I greatly admire and respect your expertise and love of Montana and the agriculture industry. It has truly been a privilege working with you and for *Western Ag Reporter*. To John Clayton, I humbly thank you for your writer's advice. It helped me consolidate my information while authoring this book. Thank you to Montana Fish Wildlife and Parks and Wade Geraets, Jason Rhoten and Robert Gibson; the Red Lodge Carnegie Library and Jodie Moore; the Carbon County Historical Society and Samantha Long; the Montana Historical Society; the Yellowstone Historic Society and Kathryn McKee; Colleen Kilbane, Heart Four Bar Photography; Nicole O'Shea for her beautiful photography

with Barrie; Tim Racicot for providing his family crayfish recipe several years ago at the inception of this project; Earlywood (www.earlywooddesigns.com); Roosevelt Junior High youth cooks; and the Rocky Mountain Elk Foundation. I am forever thankful to Merv Coleman (www.mervcoleman.com) for his time, photographic expertise and calm presence during our photo shoot. Working with him and seeing a vision I had hoped for since starting this project was pure joy, and he made it happen.

An enormous thank-you goes to my husband and four children for their ongoing support and cheerleading as this book was created, and to my extended family. They taste-tested, pulled innards out, skinned, deboned snakes, fished, hunted, photographed, put out fires (real ones) and waited patiently as I prepared these meals and worked toward the goals and completion of this book. I couldn't have done it without them, especially when handling the rattlesnake.

A very whole-hearted and sincere thank-you to Barrie Boulds for sharing her recipes and talents toward creating these meals, which gave me a new confidence and love for cooking and preparing gourmet meals, and for coming along on this publishing journey. It has been a true adventure. You have put your heart into these recipes throughout your career, and I appreciate learning how to make these decadent dishes, along with all your time, patience and teaching along the way.

Last, but certainly not the least, thank you to our senior editor, Artie Crisp, at Arcadia Publishing and The History Press for seeing the vision and opportunities for this cookbook. His guidance, expertise and professionalism in every aspect of this book have been priceless. From across the country, I could hear his genuine interest and eager anticipation for this project in his phone calls and e-mails. It has been a true pleasure and honor working with him and Arcadia Publishing and The History Press. To all, I sincerely and graciously thank you.

—Jean Petersen

First, I want to thank Jean Petersen for her tireless work, dedication, persistence and believing in this book from beginning to fruition. She went above and beyond by helping me organize my recipes written on legal pads, scratch paper and napkins, writing down the recipes from my memories—almost everything short of toilet paper—and also testing them out in the kitchen. Thank you for believing in me and my cooking talents.

A huge thank-you to Artie Crisp, our senior editor, and Arcadia Publishing and The History Press for wanting to share with the world that Montana is a foodie treasure, with talented chefs, an abundance of local and wild foods and amazing natural resources. Thank you to the creative people and team for helping us make this book.

Also, I need to thank everyone who has contributed or passed down recipes for this book: Grandma Vivian (O'Toole) Boulds, Lorna Vannatta, Francesco Ducrey Giordano, June Shy Face, Tim Racicot, Lucille Lien, Lois O'Toole and Benita Trottier and the Tim Trottier family.

Thank you to my dad, Raymond Boulds, for always having a garden. You showed me the importance of local foods and sustainability. Thank you for immersing me in the Native American culture and foods of eastern Montana, by taking me to powwows and feeds as a small child. Thank you for sharing your knowledge of plants, agriculture, geology, birds and natural medicinal plants and foods on our many walks.

Chef Michael McAuliffe, thank you for taking every single one of my phone calls and questions throughout the development of my cooking abilities and career over the years. Thank you to Chef Eric Trager for being an inspiration to me and to all the other chefs whom I aspire to be. Thank you to everyone who believed in me, supported me and loves my food. I love you all and am so very grateful for you.

Lastly, I'd like to thank my daughter, Sydney, for being my guinea pig all these years in my "test" kitchen, whether she liked it or not.

—BARRIE BOULDS

Merv Coleman

INTRODUCTION

As I gaze out at my horizon, the mountain-scape and bluebird big sky look as if they are commissioned paintings of my Montana view. Driving our back roads at dusk to watch more than one hundred bull elk silhouette themselves against the setting orange sun, fishing in crystal-clear mountain lakes to reel in more than twenty fish during a hike's lunch break and walking the rolling hills and dipping coulees to hunt the deer salt-and-peppering the landscape is our life. It doesn't seem real, but it is our Montana lifestyle. We get to enjoy the bounty of our Big Sky plentitude, from the sky's view to its plethora of natural resources at our fingertips, as have many before us. In *The Big Sky Bounty Cookbook*, I wanted to share the abundance of traditional natural resources thriving on our Montana lands as it has been enjoyed for hundreds of

years through meals, while also connecting the rich flavors of these resources amid history and the harvest bounty of today.

This cookbook has, in a sophisticated yet straightforward manner, presented dishes based off the natural resources of our Montana land and locally sourced foods. Each dish is filled with western ingredients, rustic style and vibrant flavors as we take these traditional resources to their next level as decadent gourmet meals. Of the featured resources are meats, fish, fowl, wild game, herbs and Native American recipes specific to Montana. With Chef Boulds' talents and firsthand knowledge of how to best utilize these resources, she has created epicurean dishes using these harvests and teamed them with locally sourced products. These recipes are filled with ingredients that not only create gourmet meals but also blend flavors for any palate to enjoy, as well as any skill level to prepare. I wanted to showcase the accessibility of these products today, while also highlighting their plentitude and usefulness through historical images. The pastures and mountainsides were filled with abundance in the nineteenth-century discoveries of our state, and meals were held in the beauty of the same mountains' shadows and grassy hilltops as we have today. Historically, the natural resources included in these recipes were teamed with bounties directly from the land, not processed but picked from the yield of plenty and readily available. These bounties, such as wild garlics, sages, huckleberries, chokecherries, apples and potatoes, were filled with the rich flavors within themselves and were given the extra attention and time it required to produce a memorable meal. Chef Boulds has taken what was of yesteryear, blended it with the now and mixed flavors together to create unique meals, all with locally sourced ingredients and readily accessible from our Montana landscapes while also being inclusive of the non-chef to produce gourmet meals.

I, the non-chef, am a "rustic gourmet." Having lived with the plentitude of these resources featured, and not knowing how to prepare or having a direction to utilize these products to their potential, I felt like it was a waste of their abundance and service as the resource. I continuously wanted to prepare something more from these products, to feast on a gourmet meal of abundance like many of these historical images represent. I am rustic and unrefined in my efforts, although gourmet in my mind's thoughts and goals for preparation. Chef Boulds' recipes bridge both elements with her boasting savory ingredients, subtle panache, bursting creativity and vast knowledge of the natural resources—setting these dishes aside from any similar recipes. With each decadent meal ensemble, Chef Boulds pulls from her vast experience and native Montanan roots to produce real meals to remember and sets them over the edge for us unrefined cooks to create an exclusive gourmet meal. This book shares rustic elegance

in every dish at its finest and showcases the pride we hold in these time-honored traditional resources across the state. As you read this book and find the recipes unfold, the hope is for you to create exquisite gourmet meals, reflect on the images of old and behold the richness of provisions included in the era. May you also discover the deep-rooted abundance of natural resources and locally sourced foods we have as a sizable bounty in Big Sky country. On behalf of Chef Boulds and myself, enjoy!

—JEAN PETERSEN

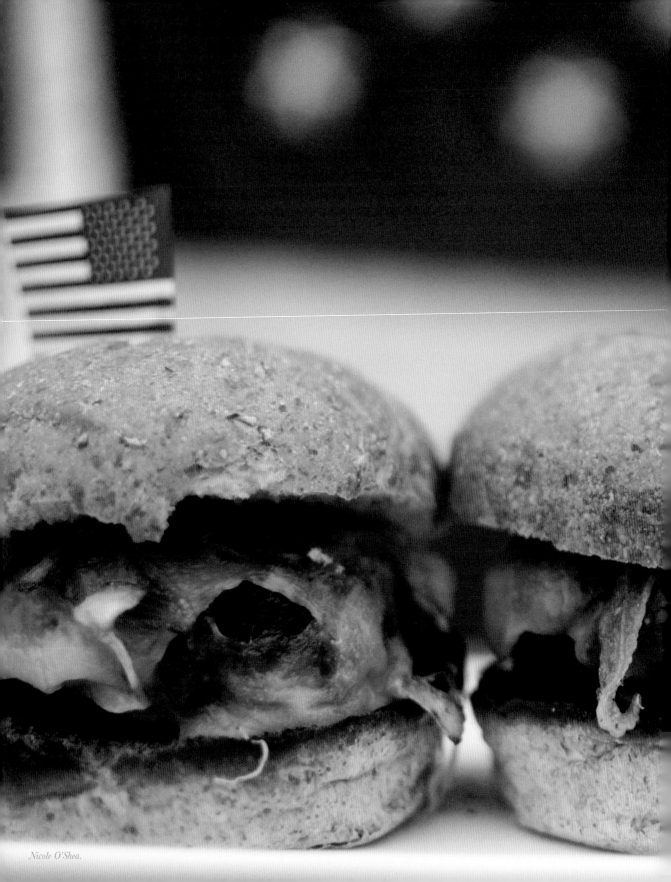

Nicole O'Shea.

PART I. APPETIZERS

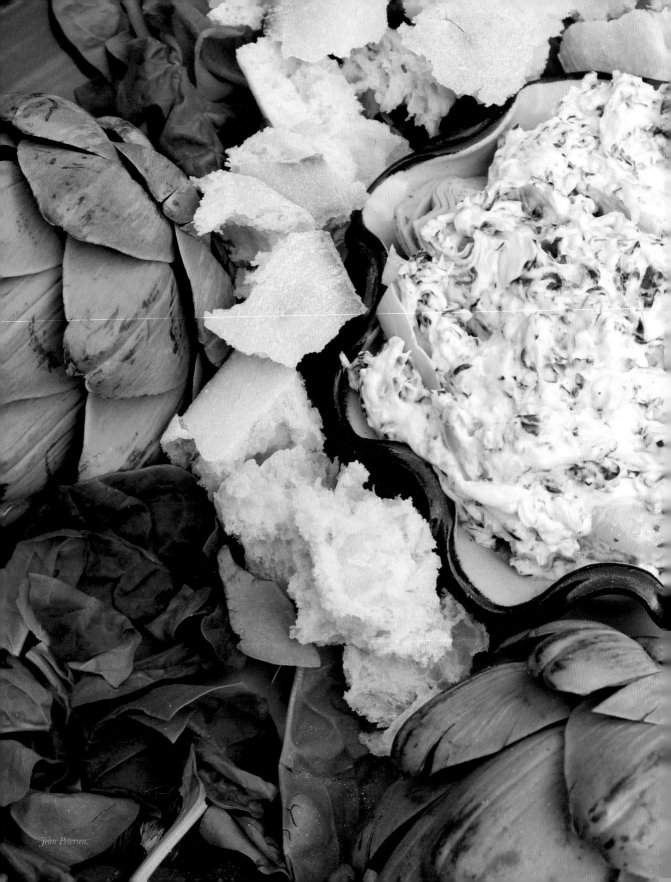

Jean Petersen.

ARTICHOKE AND SPINACH DIP

SERVES 4-6

"THIS WAS ONE OF MY MOST POPULAR DISHES AT
MY RESTAURANT, SYDNEY'S MOUNTAIN BISTRO,
AND ONE OF MY MOST FAVORITE RECIPES TO SHARE
WHEN ASKED."—CHEF BOULDS

1½ pounds cream cheese, softened
2 cups sour cream
1 cup quality mayonnaise, preferably Best
 or Hellman's
4 cups shredded parmesan cheese
10–12 garlic cloves, minced
1½ teaspoons kosher salt
3 14-ounce cans artichoke hearts, drained,
 rinsed and crushed by hand
1 pound baby spinach, or 10 cups loosely
 packed, cleaned
French bread

Preheat oven to 375 degrees. Mix together in
food processor or by hand the cream cheese, sour
cream, mayonnaise, 2 cups parmesan, garlic and
salt. In a bowl, mix together artichoke hearts,
spinach and the cheese mixture.

Place into 9x13 glass dish (or individual oven-
proof bowls) and top with remaining 2 cups
parmesan. Bake until bubbly and hot, about 25
minutes. Serve with crusty French bread.

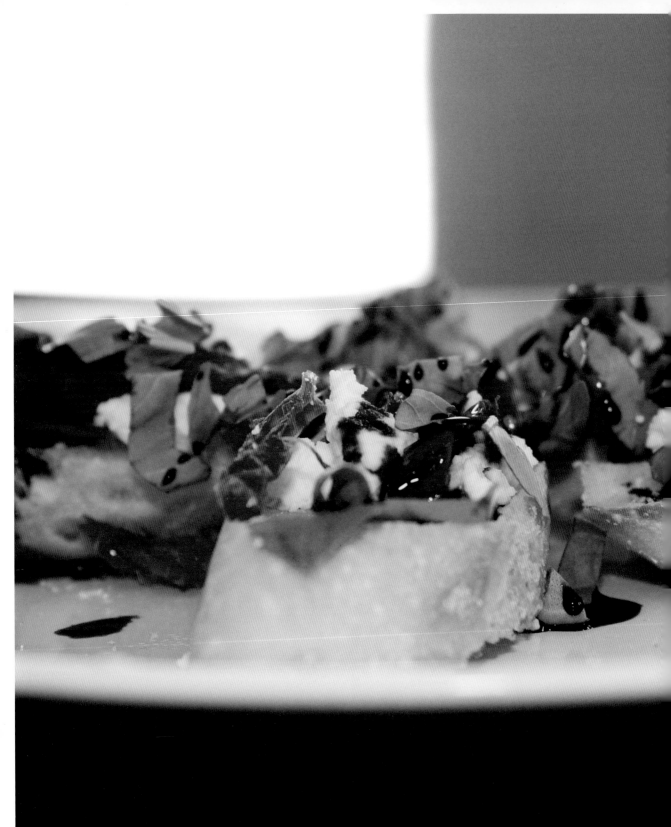

Barrie Boulds.

CROSTINI *with* SUNDRIED TOMATOES AND FETA CHEESE

SERVES 8–10

"THIS IS ANOTHER SIMPLE BUT ELEGANT APPETIZER YOU CAN 'WOW' YOUR GUESTS WITH. IF YOU ARE
RUSHED FOR TIME, IT IS A FAST APPETIZER YOU CAN THROW TOGETHER AT THE LAST MINUTE."
—CHEF BOULDS

1 loaf French baguette bread
Olive oil
8-ounce jar or 1 cup fresh
 sundried tomatoes, sliced into strips
6 ounces crumbled feta cheese
Fresh sliced basil
Balsamic Reduction*

***BALSAMIC REDUCTION**
2 cups balsamic vinegar

Slice French baguette bread in diagonal slices and brush with olive oil. Place on grill to make grill marks or toast in a 350-degree oven. Top the bread with sundried tomatoes, feta cheese and sliced basil, and drizzle Balsamic Reduction over the top.

FOR THE REDUCTION: *Place balsamic vinegar in a small saucepan and bring to a boil. Turn heat down to medium low and reduce to one-third of its original consistency or until it coats the back of a spoon. Remove from heat and cool.*

BAKED TOMATO TARTS
with GOAT CHEESE MOUSSE

SERVES 6

"GOAT CHEESE IS A LIGHT, DELICATE CHEESE. ITS FLAVOR IS TANGY. I LIKE TO USE LOCAL DAIRIES, SUCH AS AMALTHEIA ORGANIC DAIRY IN BELGRADE. THEIR CHEESE HAS A SLIGHT TANG, MAKING THIS DISH'S LAYERS SAVORY AND COMPLEX FOR BEING SO SIMPLE."
—CHEF BOULDS

1 sheet frozen puff pastry,
 defrosted in refrigerator
6 small pie tins (3- to 4-inch diameter)
3 teaspoons sherry vinegar
Olive oil
3 large ripe garden tomatoes,
 halved lengthwise and squeezed to
 remove excess seeds
Goat Cheese Mousse*
Fresh basil, sliced in thin strips
Freshly ground black pepper
Balsamic Reduction (see page 27)

*GOAT CHEESE MOUSSE

5 ounces goat cheese,
 room temperature
½ cup heavy whipping cream
2 tablespoons diced chives

Preheat oven to 425 degrees. Thaw and cut puff pastry into circles the size of the pie tins. Set aside.

Layer in pie tins ½ teaspoon sherry vinegar and a drizzle of olive oil on bottom, top with halves of garden tomatoes (cut side down) and cover with puff pastry. Place in oven until puff pastry turns a golden brown, about 10 minutes. While cooking, make Goat Cheese Mousse. Cool slightly and invert tarts onto a plate. Top with a spoonful of Goat Cheese Mousse. Garnish with basil, pepper and Balsamic Reduction.

FOR THE MOUSSE: Combine goat cheese, cream and chives. Whip together until all ingredients are even throughout the mousse. Can make a day ahead; bring to room temperature before using.

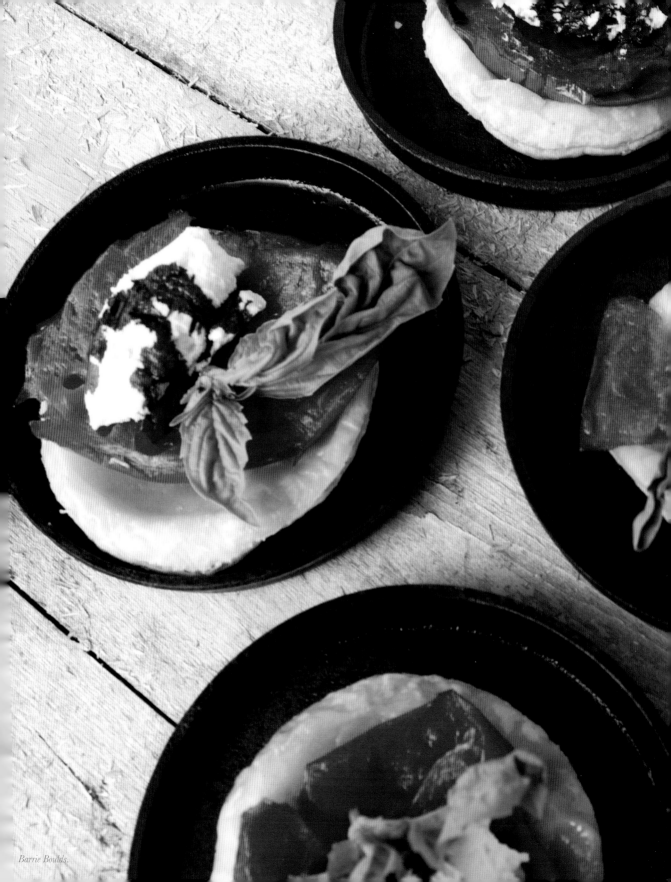

Barrie Boulds.

NATIVE AMERICAN BEEF TONGUE MINI TACOS
with FRESH PICO DE GALLO

SERVES 6–8

"MANY NATIVE AMERICANS WERE VERY POOR ON THE RESERVATIONS, SO THEY WOULD BUY THE LESSER-USED CUTS OF BEEF OR INNARDS FOR COOKING. BEFORE COLONIZATION, THE TONGUE OF CERTAIN ANIMALS, LIKE THE BISON, WERE DELICACIES AND GIVEN TO THE MEDICINE PEOPLE OF THEIR TRIBES. BEEF TONGUE HAS A DEEP, NATURALLY RICH BEEF FLAVOR, LIKE A BEEF POT ROAST."—CHEF BOULDS

3 to 4 pounds beef tongue

2 large yellow onions, peeled
 and quartered

1 whole garlic bulb, cut in half

6 bay leaves

1 tablespoon whole black peppercorns

2 tablespoons kosher salt

1 cup orange juice

1 tablespoon cumin

Mini corn or flour tortillas

Pico de Gallo*

Kosher salt and freshly ground
 black pepper

*PICO DE GALLO

½ cup fresh cilantro, leaves chopped

½ cup red onions, chopped

4 plum tomatoes, seeded and chopped

1 small white onion, chopped

2 to 3 jalapeños, seeded and minced

3 tablespoons fresh lime juice

Kosher salt and freshly ground
 black pepper to taste

Place beef tongue in stockpot or Dutch oven; add onions, garlic, bay leaves, peppercorns and salt. Pour water over until everything is covered by 2 inches. Bring to a boil, reduce heat to low, cover and simmer for 3 hours until tender. Tongue can be cooked in a crockpot overnight on low or in a pressure cooker according to manufacturer's instructions. Remove tongue from pot, discarding liquid and ingredients. With a sharp knife, remove outer skin of tongue and tendon on tongue when cool enough to handle. Chop or shred beef. Mix orange juice and cumin and add to the beef. Set aside.

Heat tortillas; add beef, Pico de Gallo and condiments to your liking.

FOR THE PICO DE GALLO: *Combine all ingredients and chill in fridge until ready to use. Let flavors meld at least 4 hours if possible.*

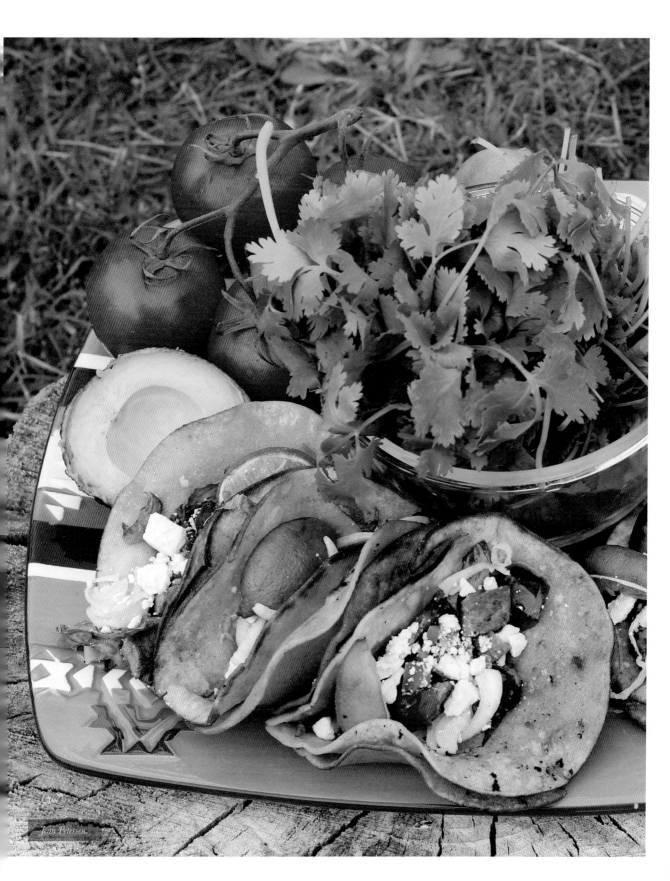

Jean Petersen.

GREAT NUMBERS OF BUFFALOW [*SIC*] IN EVERY DIRECTION. I THINK ABOUT 10,000 MAY BE SEEN IN VIEW.

—Sunday, June 30, 1805, William Clark

These bison numbers, as quoted from William Clark's journals, were prolific for many years but decreased rapidly with the onset of more settlers moving west and hide hunters pursuing the collection of these great animals. Bison provided the majority of the food for local people, new settlements, trading posts, railroad workers and hide hunters. A bison hide was worth a couple days' wage, and unfortunately, with this fact came the immeasurable amount of waste left to rot on the plains, which also produced a vast expansion of predators. In the winter of 1881–82, more than 250,000 bison hides were shipped from the lower Yellowstone River and western North Dakota on the Northern Pacific Railroad route—a new transportation system providing hide hunters further means for exporting these hides directly to the industrial market—and by 1883, the last of the great bison herds had been hunted to near extinction. Active conservation efforts commenced to capture, relocate and preserve these animals.

Not only was the federal government actively involved in conserving these animals by purchasing bison for shipment to Yellowstone National Park to add into the surviving twenty-five to fifty wild bison, but also private ranchers worked together to preserve their existence. In 1873, Walking Coyote—also known as Samuel Wells, a native member of the Salish people—captured seven bison calves in the surrounding Milk River area as an act of penitence for taking a second wife, which went against the Christian beliefs of his tribe and caused him to be banished. He did not want to be a tribal outcast, and the bison he captured were to allow for his tribal reinstatement. However unacceptable his tribulations may have been, as a result of his efforts, Walking Coyote played a key role in thwarting further bison preservation. Once the calves were almost a year old, he drove the animals over 250 miles south and journeyed across the Rocky Mountains to the southern portion of the Flathead Valley. Walking Coyote's determination led this herd to expand to over a dozen animals. Once he arrived at his destination, Walking Coyote then sold the small herd to Michael Pablo and Charles Allard, who were successful ranchers on the Flathead Indian Reservation, and they grew the herd to over seven hundred bison by 1896. By 1900, approximately 80 percent of the remaining bison were a result of the herd started by Walking Coyote and further developed by Pablo and Allard. Transitions and complications ensued over the next ten years. Thirty-seven of the initial bison coming from the Pablo-Allard herd were

purchased by Charles Conrad, a Kalispell banker, after Allard passed away. These bison became the original stock of the National Bison Range in Moiese, Montana.

William Hornaday had originally come to Montana in the mid-1880s to hunt and collect bison for the Smithsonian Museum that were to become part of a taxidermy display because it was believed fewer than 300 animals remained. Consequently, he was to "capture" these animals since they were swiftly disappearing. However, when he and President Theodore Roosevelt visited and observed the bison's near extinction, they realized the pressing need for increased conservation, and the American Bison Society was formed in 1905. William Hornaday became the president and Roosevelt the honorary president. In 1908, Roosevelt signed legislation and Congress moved to purchase suitable land for the preservation of the animals through the National Bison Range. This purchase was the first time Congress used tax dollars toward conserving wildlife. The more than 18,500 acres of protected land has maintained the bison's legacy through its years of conservation. The National Bison Range is a refuge and current home to 350 to 500 bison and various other native Montana wildlife.

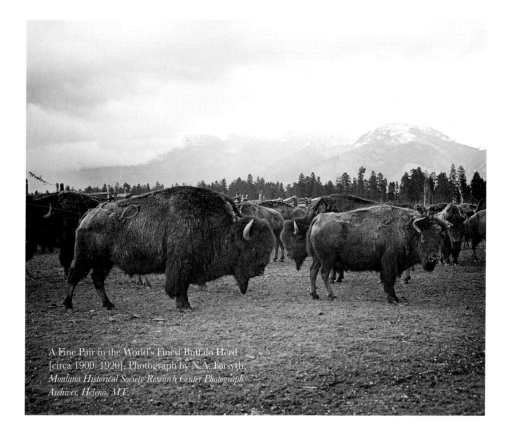

A Fine Pair in the World's Finest Buffalo Herd [circa 1900–1920]. Photograph by N.A. Forsyth, *Montana Historical Society Research Center Photograph Archives, Helena, MT.*

BISON PASTY

SERVES 4–6

"Pasties are similar to large empanadas. Bison is a trademark natural local meat. It's low in fat, lean and has a richer taste. Yellowstone National Park has one of the oldest, largest and most genetically pure bison herds in the United States, and at Sydney's Mountain Bistro, they were basically right out our back door."—Chef Boulds

Pastry Crust*
1 pound ground bison
 (also called buffalo)
1 medium yellow onion, peeled
 and finely chopped
1 garlic clove, diced
1 small rutabaga, peeled and cut
 into small cubes
1 medium russet potato, cut into
 small cubes
¼ cup chopped parsley
Kosher salt and freshly ground
 black pepper
1 beaten egg with 1 teaspoon
 water for egg wash

*PASTRY CRUST
½ cup (1 stick) unsalted butter,
 chilled and diced
1½ cups pastry flour
¼ teaspoon salt
¼ teaspoon baking soda
½ cup ice water

Barrie Boulds.

Preheat oven to 350 degrees. Prepare the pastry crust first by cutting the butter into the dry ingredients and adding ice water. Handle as little as possible. When combined, form into two balls and refrigerate for 1 hour.

Combine all the ingredients for the bison filling except the egg.

Remove dough and cut each half into two, making four equal balls. Roll out into four 8-inch circles on a floured surface. Place meat mixture on half of dough circle and fold over. Crimp the dough edges, slice three slits on top of each pasty and place on baking sheet lined with parchment paper. Brush the tops with the beaten egg wash. Bake until brown and flaky on top, about 1 hour. Serve as is or with a rich brown gravy. Dough can be divided into 8 4-inch circles to make smaller pasties.

UPON THAT DAY ANTELOPE RANGED THE HILLS WHICH SLOPED TO ALDER CREEK; ELK WERE UPON THE LOWER RIDGES OF THE SURROUNDING MOUNTAINS; ON THE HIGH RIDGES MOUNTAIN SHEEP WERE PLENTIFUL; WHILE MULE DEER WERE ALL ABOUT THE TIMBERED MOUNTAINS NEAR THE HEAD OF ALDER GULF; BEAR WERE ENTIRELY TOO NUMEROUS FOR MAN'S COMFORT. GROUSE WERE EVERYWHERE ALONG THE CREEK OF ALDER AND ITS TRIBUTARY STREAMS.—*Judge Callaway*

Pronghorn are native to North America and were said to be more prolific than bison across the open ranges of Montana at the beginning of the 1800s. However, they, too, began to drastically diminish and became virtually extinct with the onset of progress in settlements, booming mines and railroads around the later part of the nineteenth century. The Montana Fish and Game Commission, conservation-minded hunters and private landowners began to work toward these animals' conservation around 1910, and efforts to trap, transplant and learn more about the biology and handling techniques of the pronghorn helped their preservation. By about 1924, numbers across Montana, even with conservation efforts, were said to be only about 3,000. However, over the past century, these "race cars of the plains" have reestablished their numbers to over 155,000 through conservation and management.

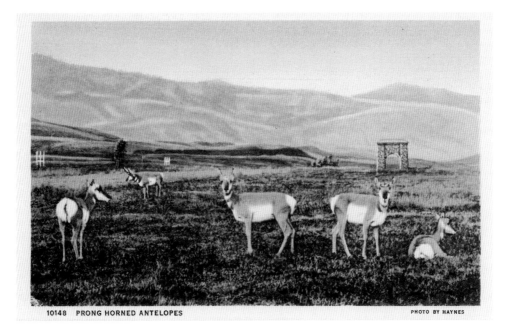

10148 PRONG HORNED ANTELOPES PHOTO BY HAYNES

Haynes Postcard No. 10148, Prong Horned Antelopes, first published circa 1935, F. Jay Haynes. *Yellowstone Historic Center Collections.*

ANTELOPE KABOBS

SERVES 4

"ANTELOPE IS ONE OF MY FAVORITE WILD GAME MEATS BESIDES ELK. IT OFTEN GETS A BAD RAP FOR BEING TOO GAMEY. BUT TO ME, IT HAS A VERY UNIQUE FLAVOR. THIS MARINADE CAN ALSO HELP PULL DOWN THE GAMEY FLAVOR AND ENHANCES THE UNIQUE FLAVOR OF THE MEAT."—CHEF BOULDS

Wooden skewers, soaked
 in water overnight
Marinade*
2 pounds antelope meat,
 cut into 1-inch pieces
2 white onions, cut
 into large pieces
2 red peppers, cut into
 large pieces
2 yellow peppers, cut
 into large pieces

*MARINADE
½ cup (1 stick) unsalted
 butter
1 teaspoon red pepper
 flakes
2 garlic cloves, minced
½ cup brown sugar
½ cup soy sauce
½ cup fresh lime juice

Prepare marinade first. Heat butter over medium-high heat and add red pepper flakes until fragrant. Add garlic and sauté 2 minutes. Then add brown sugar, soy sauce and lime juice. Bring to a boil and boil for 3 to 4 minutes or until thickened. Remove from heat and cool slightly. Set aside.

Assemble kabobs, alternating onions, red pepper, antelope, yellow pepper, etc. until you have skewers full of meat and vegetables. Once assembled, put into shallow pan and pour marinade over the kabobs. Marinate overnight for best result or for at least 4 hours. Heat grill to medium-high, shake off extra marinade and place kabobs on grill.

Grill until vegetables become slightly charred. Take off grill and let rest 5 minutes. Leftover marinade can be reduced over the stove and served in a dish alongside kabobs as a dipping sauce.

Nicole O'Shea.

BISON SLIDERS *with* CARAMELIZED ONIONS

SERVES 6

"ALWAYS COOK BISON MEDIUM-RARE TO MEDIUM, AS IT IS A VERY LEAN MEAT WITHOUT A LOT OF FAT. ITS TASTE IS SIMILAR TO BEEF, BUT IT IS HEALTHIER FOR YOU."—CHEF BOULDS

Caramelized Onions*
1¼ pounds ground bison (also called buffalo)
1 teaspoon kosher salt
½ teaspoon freshly ground black pepper
1 teaspoon Worcestershire sauce
6 100 Percent Easy Whole Wheat Rolls, sliced in half (see page 166)
Olive oil
3 slices provolone cheese, cut in half

***CARAMELIZED ONIONS**
1 tablespoon olive oil
1 tablespoon unsalted butter
2 cups thinly sliced yellow onions
1 teaspoon white sugar
Pinch of kosher salt and freshly ground black pepper

Make Caramelized Onions first. Heat cast-iron skillet with oil and butter on medium-high heat and add onions. Turn heat down to medium and stir until the onions are a deep golden-brown color. Add the sugar halfway through the process, about 30 minutes, and then add a pinch of salt and pepper. Remove onions from skillet.

In a bowl, combine ground bison, salt, pepper and Worcestershire sauce. Form six equally sized meatballs and shape into patties. Cook bison patties on a grill or in a stove-top skillet. Cook until medium-rare. Remove to platter. Brush rolls with oil and place on grill or clean skillet to slightly brown. To assemble sliders, place bison patty on bottom half of roll, layer provolone cheese on top of the patty, cover with warm Caramelized Onions and top with the remaining bun.

RATTLESNAKE CAKES *with* ROASTED RED PEPPER REMOULADE

SERVES 4–6

"I GREW UP IN EASTERN MONTANA, HOME TO TEN SNAKE SPECIES. AS SCARY AS THEY WERE AND SOUND, ONLY THE PRAIRIE RATTLESNAKE IS VENOMOUS. RATTLESNAKE CAKES TASTE LIKE SALMON CAKES AND ARE DELICIOUS AND DELICATE. THE RED PEPPER REMOULADE TAKES THESE OVER THE TOP. I LOVE TO SERVE THESE AT EVENTS SO PEOPLE CAN GET OUT OF THEIR NORM AND TRY SOMETHING THEY WOULD NEVER HAVE A CHANCE TO TRY!"—CHEF BOULDS

1 pound skinned and deboned rattlesnake meat, shredded (rattlesnake can be purchased online at exotic specialty meat stores, or substitute salmon)

4 tablespoons (½ stick) unsalted butter

4 tablespoons olive oil

1 medium sweet onion, diced fine

¾ cup celery, diced fine

1 red bell pepper, diced fine

1 yellow bell pepper, diced fine

½ cup minced fresh flat-leaf parsley

1½ tablespoons capers, drained

⅔ cup good mayonnaise, such as Best or Hellman's

1 tablespoon Dijon mustard

2 extra-large eggs, lightly beaten

½ tablespoon hot sauce, Tabasco or similar

1 teaspoon Worcestershire sauce

½ tablespoon Cajun seasoning

Kosher salt and freshly ground black pepper

½ to 1 cup panko bread crumbs, just enough until barely combined

Preheat the oven to 350 degrees. Remove rattlesnake skin if needed, lightly oil rattlesnake meat and roast for 15 minutes; remove and cool. Place 2 tablespoons of the butter, 2 tablespoons olive oil, onion, celery, red and yellow bell peppers, parsley and capers in a large sauté pan. Cook on medium-low heat until the vegetables are soft, about 18 minutes. Cool at room temperature.

Debone rattlesnake meat if needed, shred meat and then put the meat in a large bowl. Add the mayonnaise, mustard, eggs, hot sauce, Worcestershire sauce, Cajun seasoning, salt and pepper. Add the vegetable mixture and mix well. Add enough panko bread crumbs just until they hold together.

Cover and chill in the refrigerator for 30 minutes. Shape into 2- to 3-ounce cakes, about the size of ⅓ of a cup.

Heat the remaining 2 tablespoons butter and 2 tablespoons olive oil in a large sauté pan over medium heat. In batches, add the rattlesnake cakes and fry for 3 to 4 minutes on each side, until browned. Drain on paper towels and serve warm with Roasted Red Pepper Remoulade. Can be made a day ahead.

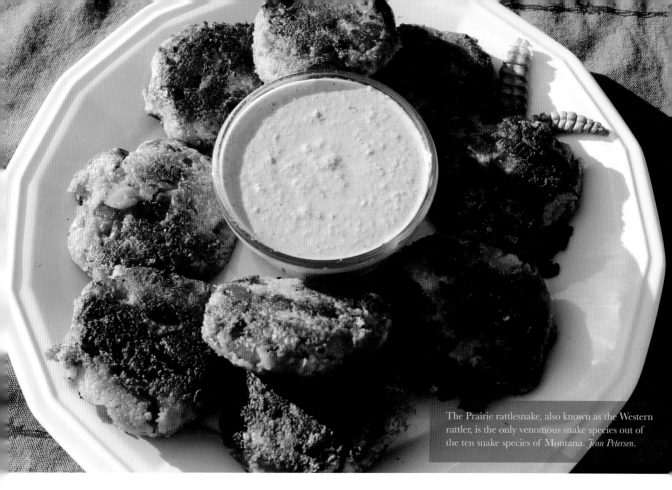

The Prairie rattlesnake, also known as the Western rattler, is the only venomous snake species out of the ten snake species of Montana. *Jean Petersen.*

ROASTED RED PEPPER REMOULADE

2 roasted red bell peppers
½ teaspoon white pepper
Pinch kosher salt
½ teaspoon Tabasco or Sriracha
⅛ teaspoon onion and garlic powder
½ tablespoon lemon juice
⅛ teaspoon dry mustard
⅛ teaspoon ground cumin
½ cup good mayonnaise, such as Best or
Hellman's

Blend all ingredients except mayonnaise in a blender until evenly blended. Add mixture to mayonnaise and mix by hand until well blended. Serve on the side or on top of the rattlesnake cakes.

MOREL MUSHROOMS

SERVES 2–4

"Morel mushrooms can be found in forest fire burn areas. They are local to Montana and are extremely expensive. Every year, we start foraging in spring when it's wet but starting to dry up, as there's a very short growing period. It is hard to get anyone to give up their morel hunting spots because they are so coveted. Morels have a nutty, rich, strong earthy flavor and are very meaty. They must be cooked and cannot be eaten raw. Morels are a delicacy in Montana."—Chef Boulds

2 cups morel mushrooms,
 cut in half lengthwise and
 cleaned
1½ tablespoons unsalted
 butter
1 tablespoon garlic, minced
¼ cup brandy, any brand
Kosher salt and freshly ground
 black pepper
Fresh thyme leaves

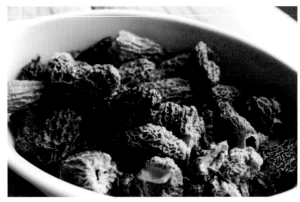

Jean Petersen.

To clean mushrooms, soak in cold water for 15 minutes, then soak two more times until water is clean. Dry on paper towels. This gets the bugs out that you don't see in the little folds and wrinkles!

Heat sauté pan to medium-high heat and then add 1 tablespoon butter and mushroom halves. Sauté for 2 minutes and add minced garlic and sauté another 30 seconds, being careful not to burn the garlic. Turn heat to low, add brandy, return heat to medium-high and reduce liquid for 1 minute. Add the remaining ½ tablespoon of butter. Season with salt and pepper to taste. Garnish with fresh thyme.

Cattle started arriving in Montana as settlers began making their way through the West. Among the first cattle were oxen found around 1850 by Captain Richard Grant's two sons, Johnny and James. Grant was previously an agent for the Hudson Bay Company and had a trading post near what is present-day Twin Bridges. These oxen were said to have been unyoked and left for dead in the Beaverhead Valley by some wandering travelers. However, when Grant's sons came across them in the spring, they were healthy and fat from grazing on the lush grasses of the valley. Travelers on the Oregon Trail could drive their oxen and cattle back and forth to the lush valley's grasses. A Jesuit priest, Father DeSmet, also utilized the Oregon Trail to grow a herd of more than one thousand cattle in the Mission Valley in the early 1850s. He primarily used the beef to assist in feeding the Native Americans who lived on the Flathead Indian Reservation, whom he missioned. The discovery of gold in 1854 and mining camps sent prospectors to Montana in masses, and cattle were needed to feed the growing populations. Many of these first cattle were trailed from Oregon and were descendants of Spanish cattle found in Mexico and California. These cattle were used to feed the growing camps and population. The American Fur Company brought cattle to eastern Montana in 1862. From then on, the great expansion of cattle to Montana further developed due to the fertile open grasslands, the availability of free government land to help grow these herds, the expansion of the railroad and the decimation of bison and various other wildlife.

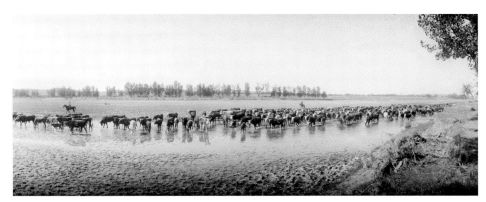

"Cattle. Throwing big Hat X herd on water. Big Dry. Northern Montana." 1904 [view of cowboys on horseback with herd of cattle in river]. Photograph by L.A. Huffman. *Montana Historical Society Research Center Photograph Archives, Helena, MT.*

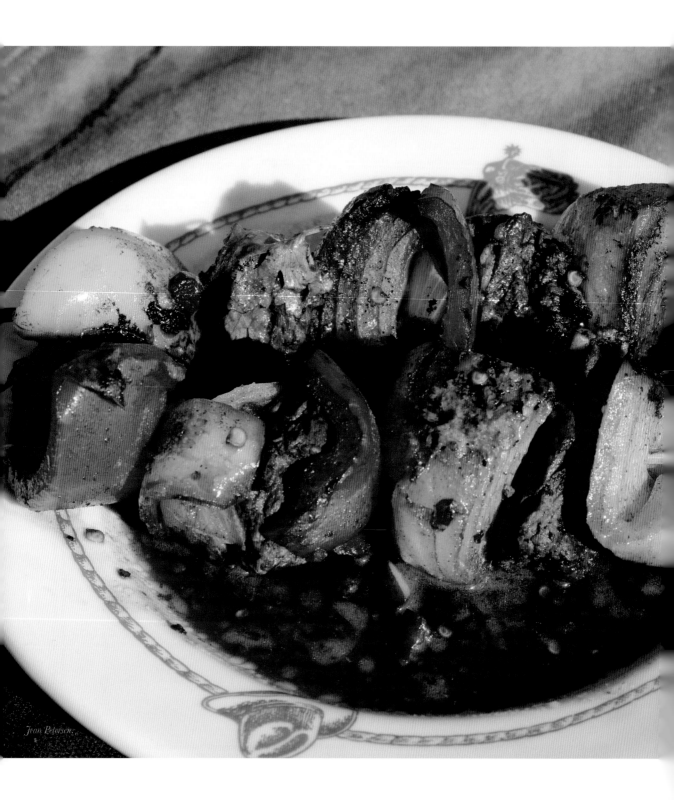

Jean Petersen

MONTANA RIBEYE SKEWERS

SERVES 4–6

"RIBEYE SKEWERS ARE A GREAT BARBECUE CROWD PLEASER. I'M ALWAYS LOOKING FOR ALTERNATIVE RECIPES TO USE FOR RIBEYE SKEWERS, AND THESE ARE EASY TO MAKE AND DELICIOUS WITH THE SAUCE. I LOVE THESE OVER MASHED POTATOES."
—CHEF BOULDS

Wooden skewers,
 soaked overnight in water
2 pounds ribeye beef cut
 into 1½-inch chunks
4 to 5 large yellow onions
4 large mixed red, yellow
 and orange peppers
2 sliced scallions, white and
 green parts

MARINADE & SAUCE
½ cup (1 stick) unsalted
 butter
1 teaspoon dried crushed
 red pepper
1 large garlic clove, minced
½ cup packed brown sugar
½ cup fresh lime juice
½ cup soy sauce
2 teaspoons cornstarch
 dissolved in 2 teaspoons
 water

Prepare marinade and sauce first. Combine butter, red pepper, garlic, brown sugar, lime juice, soy sauce and cornstarch mix in a medium saucepan and bring to a boil. Boil for 2 minutes and then turn down to medium-low until it's thickened and coats the back of a spoon. Cool and reserve one-third of sauce for later.

Cut ribeye meat into 1½-inch chunks and thread on soaked skewers, alternating among meat, onions and peppers. Marinate the meat in the sauce for 2 to 3 hours before grilling or pan searing; keep refrigerated. Remove the marinated meat from the refrigerator and allow it to come to room temperature. Heat grill or sauté pan on medium-high heat and cook on each side until the vegetables are tender and browned. Heat remaining one-third of sauce and pour over the beef skewers. Garnish with sliced scallions. Can be served over mashed potatoes.

SUGAR TEQUILA SHRIMP

SERVES 6-8

"It is really important as consumers to buy wild American-caught shrimp. I will not buy any shrimp unless I know that it is American shrimp because with other shrimp, you have no idea where it is coming from. It is sustainable, ethical and you're supporting local American businesses."—Chef Boulds

2 to 3 pounds wild American shrimp, tail on, peeled and deveined
½ cup kosher salt
½ cup white sugar
2 cups warm water
2 cups ice
1 tablespoon olive oil
Cajun or Old Bay seasoning

SHRIMP COCKTAIL SAUCE

1 cup ketchup
3 tablespoons grated onion
1 tablespoon Worcestershire sauce
2 tablespoons lemon juice and zest of ½ of a lemon
2 tablespoons chili sauce
2 tablespoons combined fresh tarragon and parsley
Freshly ground black pepper
Horseradish and tequila to taste (start with 1 tablespoon each and adjust to your liking)

FOR THE COCKTAIL SAUCE: Stir together ketchup, grated onion, Worcestershire sauce, lemon juice, lemon zest and chili sauce. Finally, add tarragon, parsley, pepper, horseradish and tequila to taste. Cover and refrigerate 2 to 3 hours.

Place the shrimp in a large bowl and rinse off to clean. Place salt and sugar in a bowl, pour over 2 cups of warm water and stir until it's dissolved. Once this is dissolved, add the ice to cool. Place the shrimp in brine mixture and brine for no longer than 30 minutes before cooking. Before cooking the shrimp, rinse in cold water and dry on paper towels. Toss the shrimp in olive oil and sprinkle with Cajun or Old Bay seasoning. Sauté in pan on medium or on a broiler sheet until the shrimp turn pink, turning once. Let the shrimp cool and refrigerate until cold or overnight. Serve with chilled cocktail sauce.

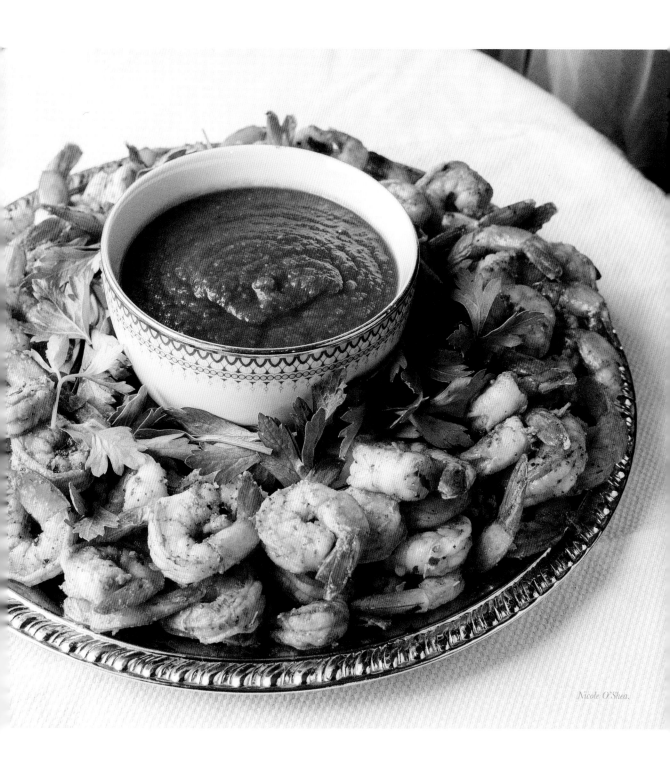

Nicole O'Shea

Salmon is a little-known secret in Montana. While these delicious fish aren't indigenous, they have been stocked in Fort Peck Reservoir since the late 1940s and early 1950s. The first salmon stocked were the Kokanee salmon, and Coho were stocked in the late 1960s and through the early 1970s. Chinook salmon were introduced in the Missouri River in 1971 and 1972 and then stocked in Fort Peck Reservoir in 1983 and nearly every year since. They were introduced to give anglers another fish species to fish, as well as to introduce a cold-water fish into Fort Peck Reservoir's cold-water ecosystem. Chinook prey on Lake Herring (Cisco), which were also introduced in 1985–86 and are now naturally reproducing and plentiful, with a lifespan of about three to four years. July through the end of September is commonly the best time to fish Chinook salmon at Fort Peck Reservoir, but they have been known to be caught throughout the year, with the state record for largest salmon being thirty-one pounds in 1991. Montana has a snagging season, which happens from the shore between October 1 and November 30, and a spear and gig season through the ice from December 1 to March 31. Once filleted, these fish provide about 25 to 30 percent of their catch weight in meat.

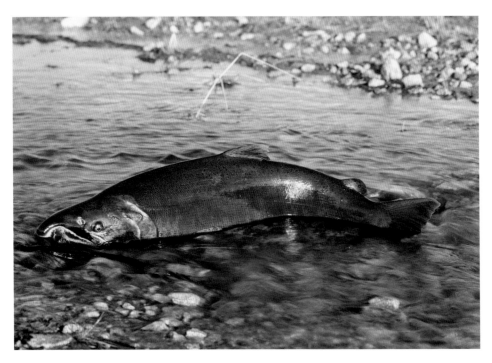

Chinook salmon. *Bureau of Land Management.*

YELLOWSTONE ROLL

2 ROLLS, SERVES 6

"It's hard to get fresh sashimi in Montana, and this appetizer is my version of a sushi roll using locally smoked salmon. The mixture of smoked salmon with crisp peppers creates a fun Montana sushi roll that is easy to make and delicious."—Chef Boulds

1½ cups prepared sushi rice

Nori sheets (found in the Asian or
 specialty food market)

3 to 4 scallions, bottoms removed,
 cut on the bias into three parts each,
 white and green parts

1 red bell pepper, sliced into long strips

1 yellow bell pepper, sliced into long strips

3 ounces smoked salmon

Wasabi

Soy sauce

Wooden sushi mat (optional)

Make sushi rice, according to package instructions, and let cool enough to handle. Place sushi rice on nori sheet until almost covering the area with the rough side of sheet on top of sushi mat, covered with plastic wrap. Place 2 to 3 each of scallions, red and yellow peppers on top of roll, letting scallions and peppers stick out on one top end. Place smoked salmon aligned with vegetables and roll sushi roll, pressing firmly to make a tight roll. Cut roll into 6 to 8 slices. Serve with wasabi and soy sauce.

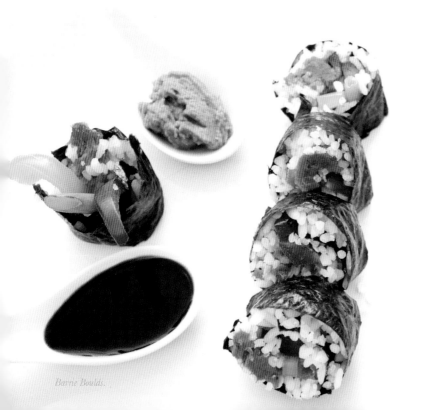

Barrie Boulds.

MOOSE STEAK FINGERS

SERVES 6-8

"Moose is very low in fat and high in protein, so if you overcook it, if not using in stew, it will become very tough and inedible. Moose meat can vary in taste depending on which season it is harvested from. The moose I've had has been extremely juicy and delicious, like a cross between grass-fed beef and elk."—Chef Boulds

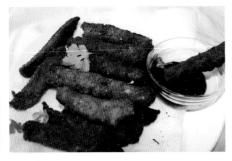

Barrie Boulds.

2 pounds sirloin moose steak, cut into
 long 1-inch strips
Kosher salt and freshly ground black pepper
2 eggs, beaten
⅓ cup whole or 2% milk
1 teaspoon Worcestershire
1 to 1½ cups all-purpose flour
2 cups bread crumbs, seasoned or unseasoned
2 teaspoons spicy Cajun seasoning
½ teaspoon black pepper
Vegetable or canola oil

Cut the moose steak into 1-inch fingers and season lightly with salt and pepper. Whisk together the eggs, milk and Worcestershire sauce in a medium bowl. Place ½ to 1 cup flour on a plate. On another plate, combine ½ cup flour, bread crumbs, Cajun seasoning and ½ teaspoon pepper. Pour about 2 inches of vegetable oil in a Dutch oven or cast-iron skillet and heat the oil to 350 to 375 degrees. Dredge the steak pieces in flour and shake off the excess. Dip the steak pieces in the egg mixture and then coat with flour/bread crumb mixture. Fry the steak fingers, working in two batches, until they are brown on both sides and cooked medium-rare to medium, but not over medium, about 2 to 3 minutes. Place steak fingers on a wire rack or plate with paper towels to drain off excess grease drippings.

GRILLED MONTANA OYSTERS

SERVES 4–6

"This is my version of Oysters Rockefeller. It's beautiful on the grill or on an open fire and tastes even better off."—Chef Boulds

½ cup (1 stick) unsalted butter, room temperature

3 to 4 garlic cloves, minced

12 to 18 large whole oysters on the half shell

Fresh Italian parsley leaves

1 to 2 lemons, cut into wedges

Kosher salt and freshly ground black pepper

Preheat grill to 350 degrees or to medium-high heat. Mix butter and garlic together in small bowl. Place the oysters directly on the grill using long tongs. Spoon butter-garlic mixture over the top of the oysters and cook approximately 3 to 5 minutes, until butter starts to bubble. Remove from grill. Garnish with parsley, a squeeze of lemon, salt and pepper. Serve with extra lemons.

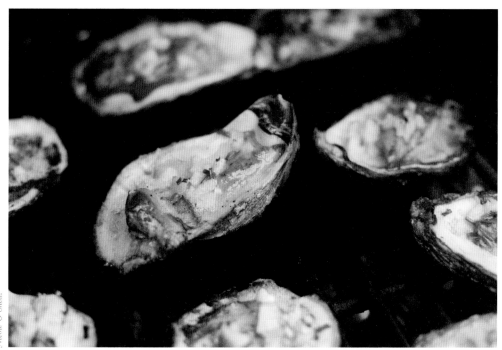

Nicole O'Shea.

ESCORTING GRAMMY
TO THE POTLUCK
ROCKY MOUNTAIN OYSTER FEED
AT BOWMAN'S CORNER

For Ethel "Grammy" Bean
by Paul Zarzyski from "The Make-Up of Ice" (1984), featured in
The Last Best Place: A Montana Anthology

Lean Ray Krone bellers through a fat cumulus
cloud of Rum-Soaked Wagonmaster Conestoga
Stogie smoke he blows across the room,
"They travel in 2's, so better eat them even
boys, or kiss good luck good-bye for good."
Tonight the calf nuts, beer batter–dipped
By the hundreds, come heaped
And steaming on 2- by 3-foot trays
From the kitchen—deep-fat fryers
Crackling like irons searing hide.

And each family, ranching Augusta
Flat Creek country, brings its own brand
Of sourdough hardrolls, beans, gelatins,
Slaws and sauces, custard and mincemeat
Pies to partner-up to the main chuck.

At the bar, a puncher grabs a cow-
poxed handful—7 of the little buggers—
Feeding them like pistachios
From palm to pinch fingers to flick-
of-the-wrist toss on target.
Grammy, a spring filly at 86, sips
a whiskey-ditch in one hand, scoops
the crispy nuggets to her platter
with the other, forks a couple
and goes on talking Hereford bulls.

And me, a real greenhorn to this cowboy
caviar—I take to them like a pup
to a hoof paring, a porky
to a lathered saddle, a packrat
to a snooseebox full of silver rivets.
I skip the trimmings, save every cubic inch
of plate and belly for these kernels,
tender nubbins I chew and chew till the last
pair, left for luck, nuzzle on the tray
like a skylined brace of round bales.

A cattleland Saturday grand time with Grammy
is chowing down on prairies pecans, then driving
the dark-as-the-inside-of-a-cow grangehall
Trail home to dream heifer-fat, bull-necked
happy dreams all night long in my Sunday boots.

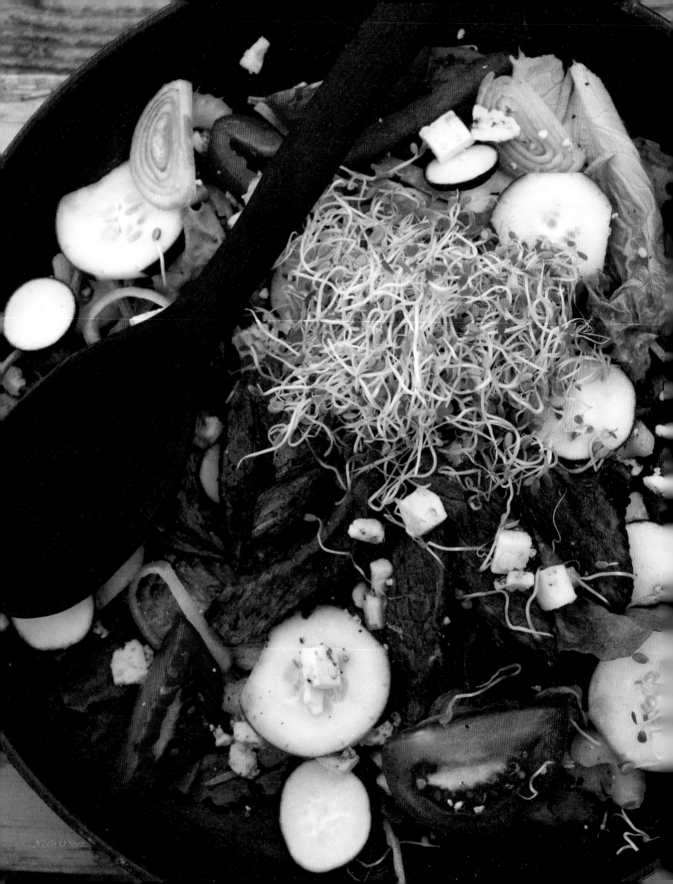

Nicole O'Shea

PART II. SOUPS AND SALADS

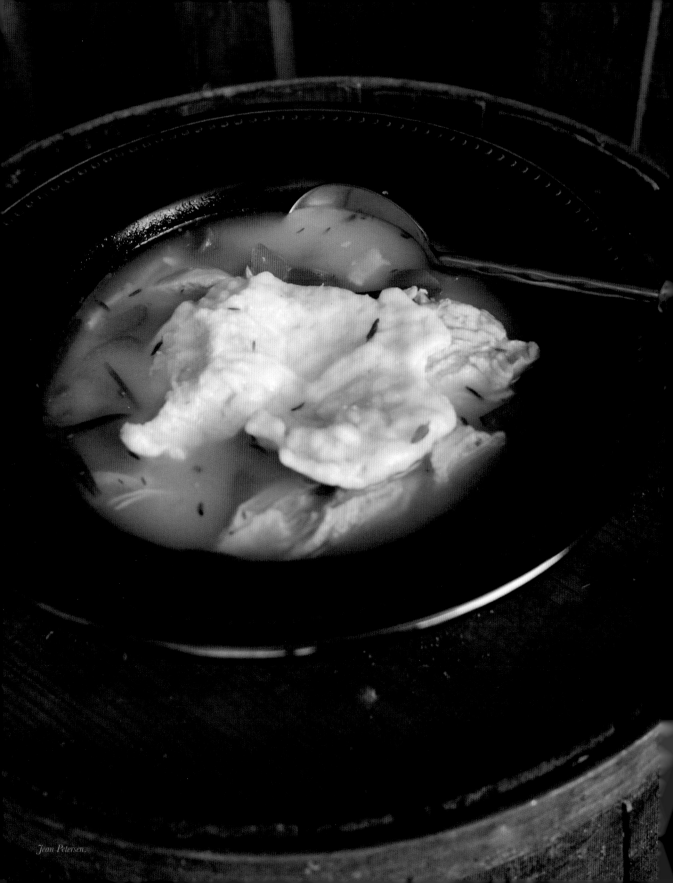

CHICKEN DUMPLING SOUP

SERVES 4–6

"I PREFER USING PLUMP, JUICY CHICKENS FROM OUR MONTANA HUTTERITE COLONIES, WHICH YOU CAN FIND AT MANY FARMERS' MARKETS. THE DUMPLING RECIPE IS COURTESY OF LORNA VANNATTA FROM FROID, MONTANA, AND IS IN ONE OF THE MANY FROID COMMUNITY COOKBOOKS SHE HAS GIFTED US. SHE TOLD ME THE SECRET TO PERFECT DUMPLINGS IS TO NEVER LIFT THE LID FOR THE ENTIRE 20 MINUTES. THIS SOUP IS MY ABSOLUTE FAVORITE TO MAKE."—CHEF BOULDS

2- to 3-pound whole chicken
5 big carrots (3 reserved for soup)
1 small celery stalk (4 stems and
 ribs reserved for soup)
2 large yellow onions
8 garlic cloves
Fresh herbs (thyme, rosemary, sage,
 basil and cilantro)
3½ quarts (14 cups) water
Kosher salt and freshly ground black
 pepper to taste
Homemade chicken stock,
 preferred, for extra taste or
 bouillon cubes (see page 175)

EGG DUMPLINGS
3 eggs
½ teaspoon salt
½ cup whole or 2% milk
1½ cups all-purpose flour

Put whole chicken in stockpot with 2 carrots, celery stalk, 1 onion and 5 garlic cloves, all roughly chopped. Add a sprig each of herbs. Pour 3½ quarts of water over chicken. Bring to a boil and turn to medium-low heat for 1 to 1½ hours, until chicken starts to come off the bone. When done, remove chicken, strain liquid, reserve for soup and discard vegetables and herbs. Let chicken cool and pull white and dark meats off the bone. Make egg dumplings while chicken is cooling. Mix eggs, salt and milk well. Blend in flour. Once egg dumplings are prepared, dice remaining carrots, celery, onion and garlic and sauté for 2 minutes. Add chicken meat, herbs to your liking and reserved chicken stock. Bring to a boil and add prepared egg dumplings. Drop by teaspoonfuls into boiling soup. Cook covered for 20 minutes. To avoid dumpling sticking to the spoon, first dip spoon into hot liquid before dropping. Extra chicken stock or bouillon cubes can be added if more flavor is needed.

WOJAPE (CHOKECHERRY SOUP)

SERVES 6-8

"WE LEARNED HOW TO MAKE THIS IN HOME ECONOMICS CLASS ON THE FORT PECK ASSINIBOINE AND SIOUX RESERVATION IN THE SIXTH GRADE FROM A NATIVE WOMAN NAMED PAT CRAWFORD. CHOKECHERRIES ARE ALL OVER THE RIVERBANKS IN EASTERN MONTANA. WE WOULD FLOAT DOWN THE MISSOURI AND POPLAR RIVERS EATING CHOKECHERRIES ALL DAY. OUR FINGERS AND FACES WOULD BE STAINED THEIR PURPLE-RED COLOR. TO MAKE THIS MORE ELEGANT, I ADD LEMON ZEST AND A DOLLOP OF SOUR CREAM OR GOAT CHEESE."—CHEF BOULDS

2 quarts (8 cups) water
1½ to 2 cups white sugar or ¾ cup honey
5 pounds fresh, washed chokecherries
2 tablespoons cornstarch mixed with equal
 parts cold water
Sour cream, crème fraiche or goat cheese
 (optional)
Zest of 1 lemon (optional)

Add the water and sugar to a large stain-resistant pot with the chokecherries. Slightly smash the chokecherries with a potato masher or with the back of a spoon; do not puree. Bring to a boil, reduce the heat to medium and cook for 30 minutes. You do not have to strain chokecherries, as the pits go to the bottom of the pot. Add the cornstarch mix and stir until it reaches your desired thickness. Serve hot or cold. You can add a dollop of sour cream, crème fraiche or goat cheese with lemon zest.

Can be served with Fry Bread (see page 96) or Gaboo Boo Bread (see page 113).

Collectively known with its common name as a part of the stone fruit family, the chokecherry shrub and tree is a natural across Montana. It's known for its jellies, syrups, sauces, jams and wine and is widely utilized in Native American cultures, which consider the vegetative parts of the plants medicinal as well. These self-fruitful "bushes" productive lifespan is about forty years, and they can produce an average yield of about thirty pounds of fruit per year. These bush cherries can grow in thickets and upward of twenty feet. While these dark reddish-purple berries pop right off their weak-stemmed branches, don't be fooled; their leaves, seeds and stems have been known to be toxic to children and livestock prior to the fruit's maturity. After the fact, those elements are considered somewhat nontoxic, so just stick to the chokecherry for its unique and fruit-filled bounty.

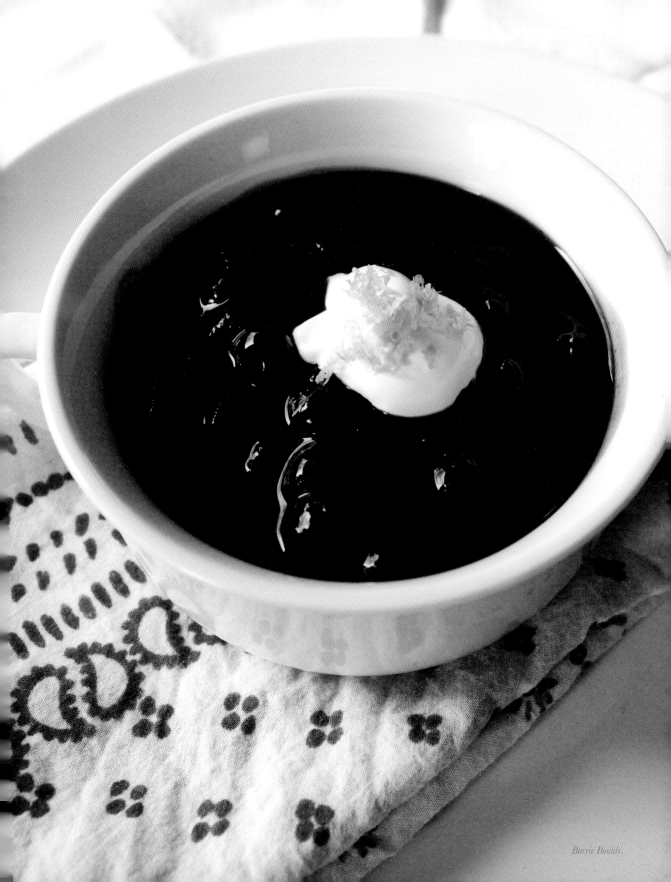

Barrie Boulds.

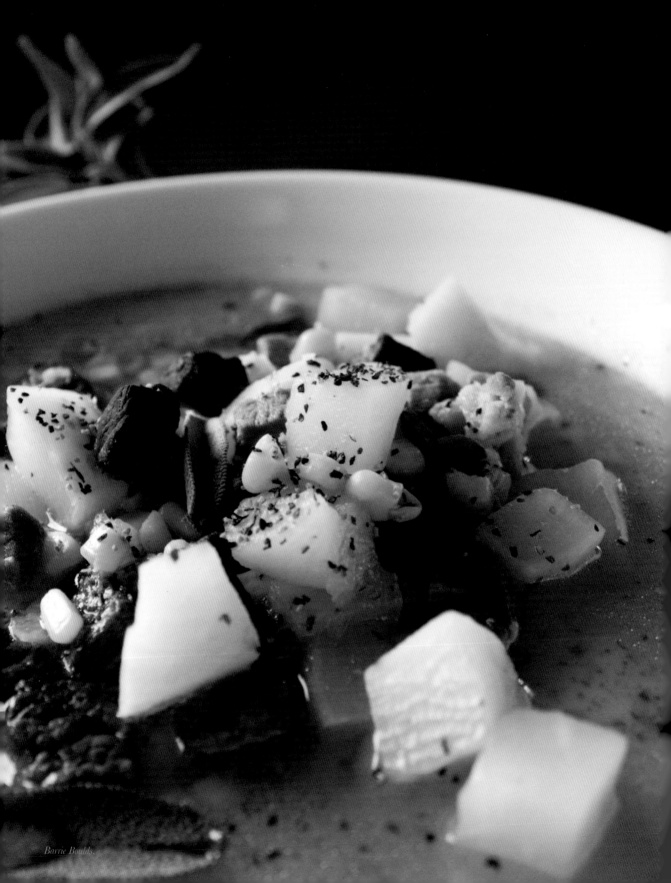

Barrie Boulds.

"PAPA" LAKOTA DRIED MEAT SOUP

SERVES 8–12

"This is a traditional Native American soup. While hunting and gathering throughout each season, Native Americans dried their meats to preserve them. I remember having this soup at the last Poplar Iron Ring pow wow of the season. This soup is very flavorful, so no extra seasonings are really needed. All fresh ingredients can be used for this recipe as well."
—Chef Boulds

1 pound (2 cups) dried deer meat
 (backstrap or hindquarters work best)
1 cup Morton's Tender Quick Home Meat
 Cure (found in the dried spices aisle of the
 grocery store) mixed with 4 cups
 cool water
4 quarts (16 cups) of water
1 pound (2 cups) dried turnips
½ pound (1 cup) dried corn
¼ pound (1 cup) salt pork, diced (bacon-like
 consistency)
1½ teaspoons freshly ground black pepper
Fresh sage or thyme (optional)

Cut meat into thin, long strips. Take meat strips and poke a toothpick through the top. Hang from the top wire rack in oven, with a drip pan beneath, at 220 degrees until dry, 2 to 3 hours. If you have a food dehydrator, dry your meat according to the directions.

Wash dried meat and soak overnight in meat cure brine (dissolve 1 cup Morton's in 4 cups cool water). Drain water and thoroughly rinse meat. Cut the meat into bite-size pieces. Add 4 quarts of fresh water to the dried meat with pepper. Bring to a boil and then add dried turnips, corn and pork. Bring to a boil again and reduce heat to low. Cook for 1 hour, until meat and vegetables are tender. Season to taste with your choice of fresh herbs.

NOTE: If using fresh ingredients, adjust water and cooking times accordingly.

Sioux woman cooking.

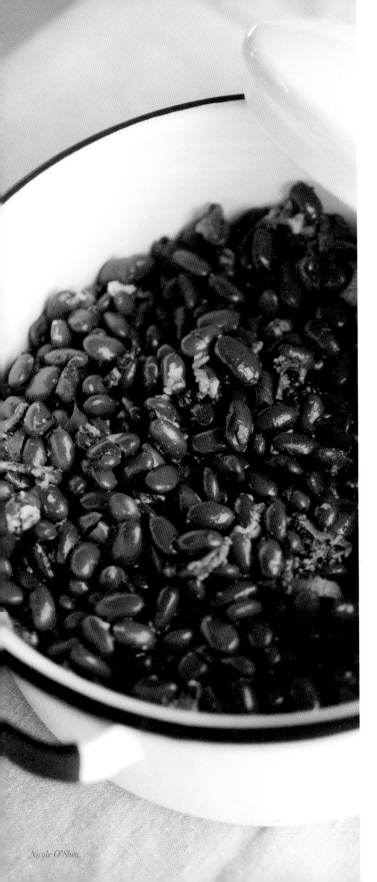

Nicole O'Shea.

GRANDMA'S BAKED BEANS

SERVES 4–6

"This was my dad's favorite bean recipe! Everyone who likes beans and has had these beans loves them. I still have the original handwritten recipe on a small piece of paper that is at least sixty years old. This is a barbecue and picnic must!"—Chef Boulds

2 cups dried beans
 (navy, butter beans or pinto)
1 teaspoon kosher salt
½ teaspoon freshly ground
 black pepper
3 tablespoons blackstrap molasses
2 tablespoons dark Karo syrup
½ cup brown sugar (about a handful)
1 pound bacon, diced

Soak dry beans overnight in a large pot. The next day, add enough water to the same pot to cover beans and boil for 30 minutes. Drain water and run hot water over them. This helps the beans to not become mushy. Pour beans into a heavy pan or Dutch oven and add salt, pepper, blackstrap molasses, dark Karo syrup and brown sugar and stir. Mix in bacon and cover beans with 1 to 2 inches of water. Slowly bake covered in oven for 3 to 4 hours at 275 to 300 degrees or in a roaster. Make sure to watch the beans and add hot water as needed.

TWICE BAKED POTATO SOUP

SERVES 6–8

"This recipe was thrown together one night at my restaurant when I ran out of the nightly soup. I had leftover potatoes from the night before and everything else to make this quickly come together. It became one of the most requested soups in the winter. You can always add or take away ingredients to this soup to change it up. It's perfect for a cold winter night curled up on the couch with a bowl of this comfort food."—Chef Boulds

4 bacon slices, crisped and chopped

2 celery ribs, small dice

1 small onion, small dice

3 small carrots, small dice

2 tablespoons (¼ stick) unsalted butter

2 tablespoons all-purpose flour

1½ to 2 quarts (6 to 8 cups) chicken stock, preferably homemade (see page 175)

1 cup heavy cream or whole milk

2 cups cooked, diced potatoes

1½ cups mashed potatoes

8 ounces cheddar cheese, grated

¾ cup sour cream

¼ cup diced scallions, white and green parts only

Kosher salt and freshly ground black pepper, to taste

Render bacon until crispy and set aside to drain on paper towels; dispose of fat in the pan or save for another recipe. Sauté celery, onion and carrots over medium-high heat. Add butter and flour to pan. Lightly brown flour and add chicken stock. Cook until bubbly and add heavy cream or milk, diced potatoes and mashed potatoes. Heat through and add cheese and sour cream. Garnish with chopped bacon and scallions. Season with salt and pepper to taste.

Nicole O'Shea.

FRENCH ONION SOUP

SERVES 6–8

"This is a knock-off of Julia Child's French Onion Soup recipe. I like to use lamb stock because it gives it a whole different depth of flavor and taste, unlike the beefy broth everyone is used to."—Chef Boulds

1 tablespoon olive oil

4 tablespoons (½ stick) unsalted butter

4 large yellow onions, skins removed
 and thinly sliced

½ teaspoon white sugar

1 teaspoon salt

3 tablespoons all-purpose flour

1½ quarts (6 cups) lamb stock,
 warmed, preferably homemade
 (see page 176) (can substitute with
 chicken stock)

1 cup dry white wine, preferably
 sauvignon blanc or pinot grigio

2 sprigs fresh thyme (1 used as garnish)

1 bay leaf

½ teaspoon ground sage

½ teaspoon ground thyme

Kosher salt and freshly ground black
 pepper

2 to 3 tablespoons cognac or brandy,
 any kind

1 grated small onion

½ cup parmesan cheese, grated

8 slices French bread (around 1 inch
 thick), brushed with olive oil and
 toasted in the broiler on each side

12 ounces emmentaler or fontina
 cheese, grated or sliced

Olive oil, for drizzling

Place heavy-bottom stockpot or Dutch oven over medium-low heat. Add 1 tablespoon of oil and 2 tablespoons of butter to the pot. Add sliced onions and stir until they are tender, about 20 minutes.

Add ½ teaspoon sugar and 1 teaspoon salt and continue to cook uncovered, stirring frequently, until the onions have reduced significantly, another 10 to 15 minutes. Once caramelized, reduce heat to medium-low and add remaining butter plus 3 tablespoons flour to the onions. Brown flour for 2 to 3 minutes, stirring constantly, so as not to burn. Stir in about 1 cup warm stock, scraping the bottom of the pan to get all the cooked onion bits up. Add the rest of the stock, wine, 1 sprig of fresh thyme, the bay leaf and the other herbs to the soup. Simmer for 45 minutes. Check the soup for seasoning and add salt and pepper if needed.

Remove the bay leaf (if you can find it) and add 2 to 3 tablespoons cognac or brandy, then grate onion into the pot. Add ½ cup of parmesan cheese directly into the soup and stir. Divide the soup into individual bowls and place toasted bread on top of the soup. Sprinkle and divide the rest of the cheese in a thick layer on top of the bread, covering it completely. Drizzle the tops with a little oil and place in a 350-degree oven or broiler until the cheese is melted and slightly brown. Remove from the oven or broiler and let it cool for a few minutes before serving. Garnish with the remaining fresh thyme.

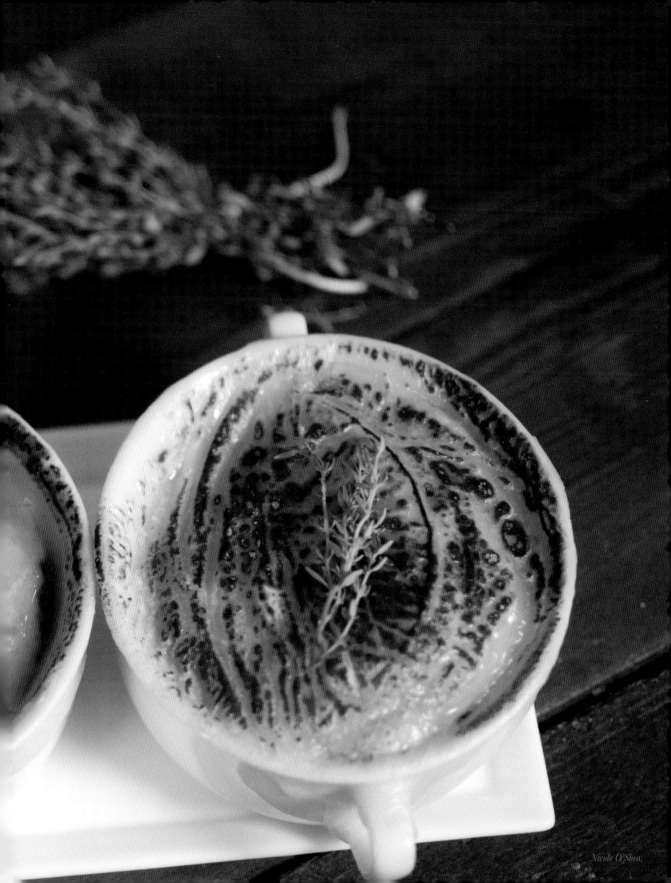

Nicole O'Shea,

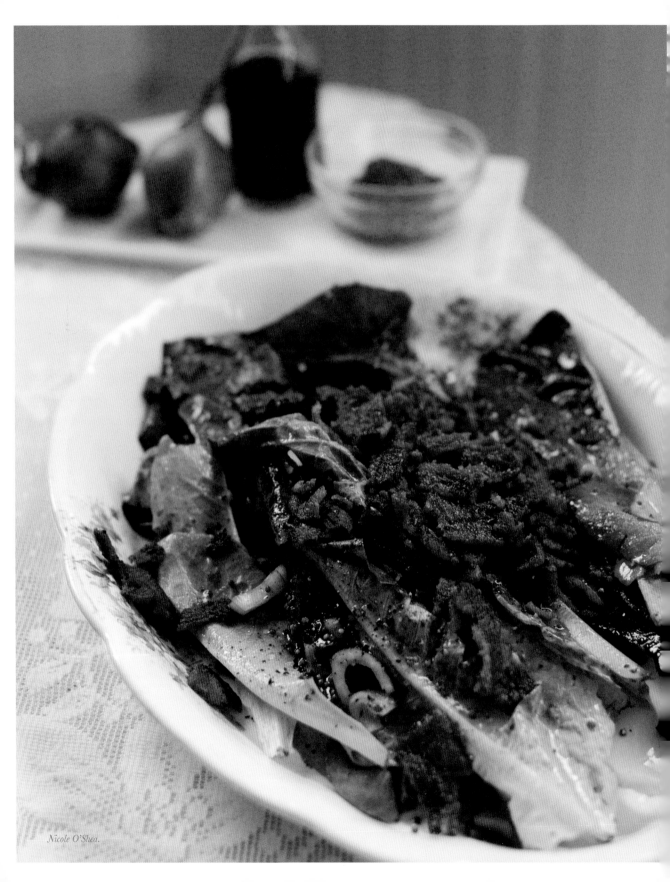

Nicole O'Shea.

GARDEN GREENS *with* HOT BACON DRESSING

SERVES 4

"THIS WAS ONE OF THE VERY FIRST SALADS I MADE AS A YOUNG ADULT WHEN I HARVESTED LETTUCE FROM MY OWN GARDEN. I COULD QUITE POSSIBLY EAT THIS EVERY NIGHT OF THE WEEK IN THE SUMMER; IT'S THAT GOOD!"—CHEF BOULDS

4 bunches of garden greens

1 shallot, cut in half and thinly sliced into half moons

8 sautéed bacon strips, crumbled

4 thick slices fresh crusty bread

2 hardboiled eggs, cut in half

Kosher salt and freshly ground black pepper, to taste

HOT BACON DRESSING

6 tablespoons (¼ cup plus 2 tablespoons) warm bacon grease

1 tablespoon whole grain mustard

2 tablespoons vinegar (sherry, red wine or apple cider)

Pinch of kosher salt and freshly ground black pepper

Wash greens, dry on paper towels and place in bowl. Sauté or bake bacon until crisp, reserve bacon grease and keep warm. Combine Hot Bacon Dressing ingredients. When dressing is finished, pour over greens until slightly wilted and divide among four plates. Top with crumbled bacon and serve with crusty bread and hardboiled eggs. Season with salt and pepper.

FOR THE DRESSING: *Whisk in bowl reserved warm bacon grease, mustard, vinegar, salt and pepper until combined. Pour over garden greens.*

HANGER STEAK SALAD *with* BLEU CHEESE DRESSING

"Hanger steak is one of the best steaks, flavor wise, you can get. The secret is getting a quick char on the outside and letting the meat rest before slicing. The salad dressing really makes this salad. Nothing beats homemade dressing over store bought. This bleu cheese dressing also makes a great dipping sauce."—Chef Boulds

SERVES 4–6

1 pound hanger steak, room temperature

Kosher salt and freshly ground black pepper

1 cucumber, sliced

2 heirloom garden tomatoes, quartered

Baby carrots, sliced or shredded

2 celery stalks, sliced

2 radishes, sliced

1 head red leaf lettuce, cleaned and chopped

1 head green leaf lettuce, cleaned and chopped

1 to 2 shallots, cut in half and sliced

8 ounces bleu cheese crumbles

BLEU CHEESE DRESSING

½ cup mayonnaise

½ cup buttermilk

½ cup sour cream

1 tablespoon lemon juice

1 teaspoon freshly ground black pepper

½ teaspoon kosher salt

4 tablespoons (¼ cup) grated onion

1 garlic clove, minced

2 teaspoons Worcestershire sauce

3 ounces bleu cheese crumbles

Preheat grill on high heat or a cast-iron pan to medium-high heat. Salt and pepper hanger steak on both sides and sauté or grill on each side for 2 to 3 minutes, until medium rare. Place on cutting board, cover with aluminum foil and let rest for 10 minutes. While steak is resting, assemble your salad with fresh vegetables and evenly distribute into four salad bowls or a large salad bowl. When steak has rested, cut on the bias in strips and place even portions on top of salads. Top with bleu cheese crumbles.

FOR THE DRESSING: *Mix mayonnaise, buttermilk and sour cream in bowl. Add lemon juice and remaining ingredients. When all ingredients are blended evenly, pour into container and keep refrigerated. Bleu cheese dressing should be semi-chunky.*

Nicole O'Shea.

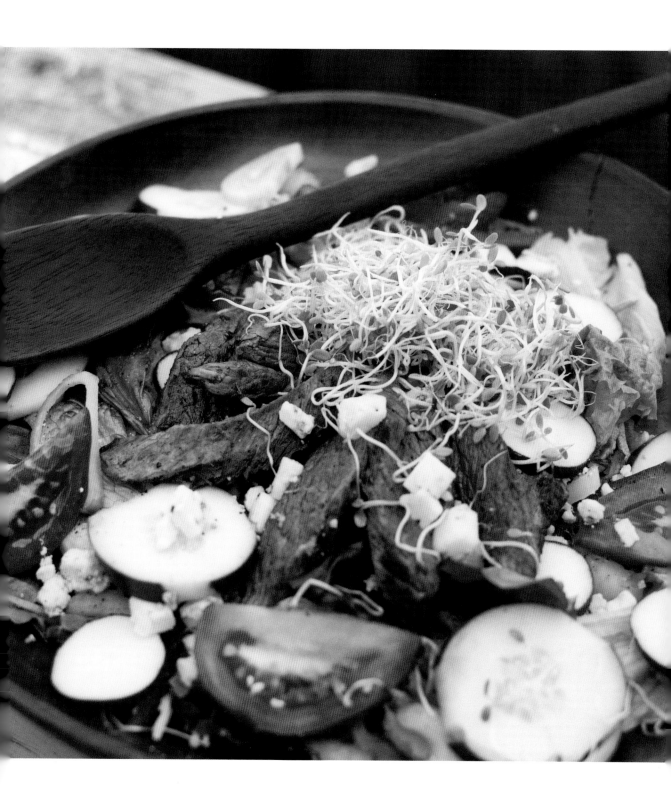

Jean Petersen.

PEAR WALNUT SALAD *with* BALSAMIC VINAIGRETTE DRESSING

SERVES 4

"THIS IS ALWAYS MY GO-TO SALAD FOR CATERED EVENTS. IT'S SWEET AND SAVORY, AND THE WALNUTS ADD A LITTLE SPECIAL SOMETHING TO AN ORDINARY SALAD."—CHEF BOULDS

4 bunches (or 5-ounce package) of mixed greens
1 pear, cut in half and sliced
¾ cup Candied Walnuts*
½ small red onion, cut in half and sliced
5 ounces bleu cheese crumbles

*CANDIED WALNUTS

1 package (12 to 16 ounces) walnut halves
2 cups white sugar, plus 2 tablespoons white sugar
2 cups water

BALSAMIC VINAIGRETTE DRESSING

½ cup balsamic vinegar
1 tablespoon stone ground mustard
½ cup shredded parmesan
1 garlic clove, minced
1 teaspoon white sugar
1 teaspoon freshly ground black pepper
1 cup olive oil

Divide mixed greens among four bowls or a large salad bowl. Portion the pear slices, walnuts and red onion on top of the salads. Top with blue cheese crumbles.

FOR THE WALNUTS: Preheat oven to 400 degrees. Prepare baking sheet with parchment paper. Place walnuts in medium saucepan and cover with the sugar and water. Boil walnuts for 10 minutes. Remove from heat and drain syrup off walnuts. Let cool and toss with 2 tablespoons of sugar. Layer walnuts on baking sheet. Bake in oven until the walnuts get crisp, watching carefully so they don't burn, about 12 minutes. Remove from oven and let walnuts cool. Store in airtight containers.

FOR THE DRESSING: In a food processor or blender, add all ingredients except oil. Blend until smooth, and then slowly add oil while blender is going. When combined, pour into container and keep refrigerated.

STRAWBERRY SPINACH SALAD
with STRAWBERRY VINAIGRETTE DRESSING

SERVES 4

"My dad had a huge garden in our backyard along with apple, crabapple and plum trees, grapevines for wine, raspberry bushes, rhubarb and a big strawberry patch. I savor the memories of picking fresh strawberries off the plant and eating them right there in the garden. He'd always let us eat as many as we wanted!"—Chef Boulds

4 bunches (or 5-ounce package)
 of fresh spinach
1½ cups fresh garden or farmers'
 market strawberries
½ medium red onion, sliced
1 cup Candied Walnuts (page 71)

STRAWBERRY–SESAME SEED VINAIGRETTE

1 cup fresh garden or farmers' market
 strawberries, tops removed and cut
 in half
½ cup white vinegar
⅛ to ¼ cup white sugar
¼ teaspoon white pepper
½ cup extra virgin olive oil
1 tablespoon white sesame or
 poppy seeds

Clean spinach of all debris; dry on paper towels. Divide mixed spinach among four salad plates or place in a large salad bowl. Quarter or slice strawberries and put over spinach, along with the red onion slices and Candied Walnuts. Serve with Strawberry–Sesame Seed Vinaigrette.

FOR THE VINAIGRETTE: In a food processor or blender, add strawberries, vinegar, sugar and white pepper. Blend until smooth, and then slowly add oil while blender is going. When combined, pour into container and stir in sesame or poppy seeds. Keep in refrigerator.

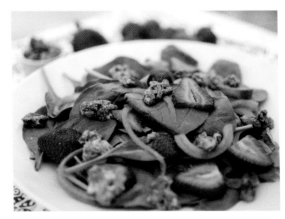

Nicole O'Shea.

In 1909, Congress passed the Enlarged Homestead Act to increase homesteaders' acreage claims from 160 to 320 acres. A land rush was spurred with the Newlands Reclamation Act of 1902, which accelerated construction of dams and irrigation projects along major rivers and waterways. With the addition of the Great Northern Pacific Railroad, which provided a way for people to come to Montana to get a free home, Montana had the most homestead claims of any state or territory, and the number of farms quadrupled during this time. Montana boasted 57,000 farms in 1910 as a result of the homesteading boom. One hundred years later, the number of farms has decreased to 27,500, but technology has increased, providing almost 60 million acres of farming and ranching lands. Some of the primary harvest crops across the state include corn, barley, oats, berries, cherries, Christmas trees, hay, mint, sugar beets, sunflowers and wheat. Other crops include apples, potatoes, dry beans, peas, flax, garlic, lentils, safflowers, mustard and squash.

Evelyn Cameron standing in horse-drawn wagon filled with corn. Jim Whaley house in background, circa 1919. Photograph by Evelyn Cameron. *Montana Historical Society Research Center Photograph Archives, Helena, MT.*

Nicole O'Shea.

PART III. MAIN ENTRÉES

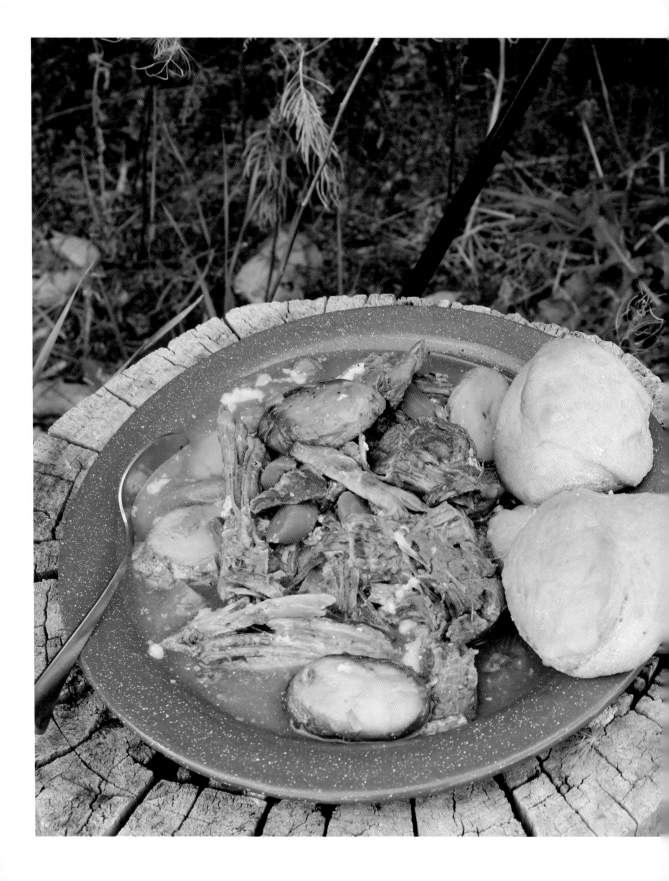

Jean Petersen.

MONTANA GUINNESS LAMB STEW

SERVES 6

"I like to use a seasonal chocolate stout beer from Red Lodge Ales over Christmas and New Year's holidays when it's available, but any local stout or porter beer will do for this recipe. It's fun to experiment with recipes. I like when people get creative and adventurous when they cook!"
—Chef Boulds

3 pounds lamb shoulder
 with a little fat, cubed into
 1-inch pieces
Kosher salt and freshly ground
 black pepper
3 large carrots, peeled and cut
 into bite-size chunks
4 stalks of celery, large dice
2 large yellow onions,
 large dice
4 garlic cloves, minced
½ cup all-purpose flour with
 pinch each of salt and
 pepper
Olive oil
12 ounces dark Montana beer,
 such as porter or stout,
 or Guinness
3 large russet potatoes, washed
and cut into bite-size
 chunks
2 quarts (8 cups) stock,
 half chicken and half beef
 (see pages 175–76)
1 bunch rosemary, thyme and
 parsley, tied together
 (reserve some parsley for
 garnish)

Season the lamb with salt and pepper.

Dredge all the vegetables except the potatoes in the flour, shaking off excess, and set aside.

In a Dutch oven or heavy-bottomed pot, add enough olive oil to coat bottom and heat to medium-high heat. Brown the lamb on all sides. Remove and reserve. In the same pot, add the vegetables and sauté until the flour is incorporated and no longer visible on the vegetables, adding more olive oil if needed. Deglaze the pan with the beer, scraping up any caramelized bits. Add the potatoes and return the lamb to the pot. Add enough stock to barely cover the stew and bring to a boil. Reduce heat to low, add the herb bouquet and simmer for 2 to 3 hours, stirring occasionally, until the meat is tender. Remove herbs and garnish with chopped parsley.

Along with cattle, sheep began to expand across the Montana landscapes in the mid- to late 1800s. Sheep were often grazed alongside cattle, and despite hearsay, there were relatively no conflicts at this time between cattle and sheep ranchers. The era of bonanza grazing was more prevalent in the 1880s, when few limitations were set for stock on the open range, and thousands of sheep along with cattle fed across the lands. This all came to an abrupt stop during the winter of 1886–87, when an early snow turned to an icy coat across the drought-worn landscape. The bonanza grazing era ended, as over 60 percent of the cattle perished that winter. From then forward, the open range was broken down into smaller land increments, thus thwarting domestic sheep herds' dramatic growth. By 1910, 5.3 million sheep grazed across Montana's landscapes. Today, Montana ranks seventh in the nation, with about 230,000 sheep in production.

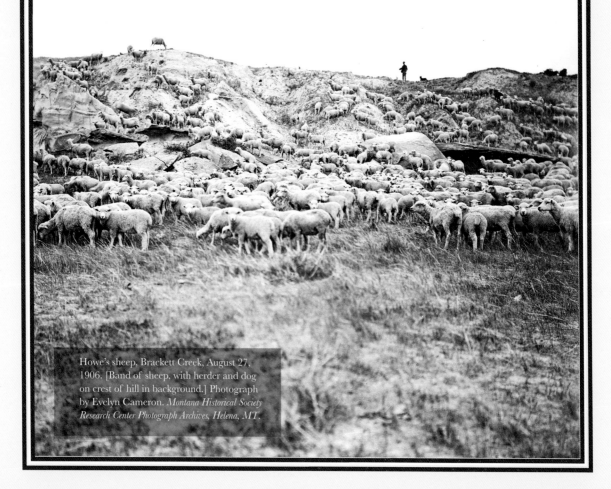

Howe's sheep, Brackett Creek, August 27, 1906. [Band of sheep, with herder and dog on crest of hill in background.] Photograph by Evelyn Cameron. *Montana Historical Society Research Center Photograph Archives, Helena, MT.*

INDIAN TACOS

MAKES 8–12 SERVINGS

"Indian Tacos are a staple food at every feed, powwow, celebration, gathering, sporting event and every other occasion you can think of on the reservation. The history of fry bread and the Indian Taco was born out of the necessity of using the government rations that were given to the Native Americans on reservations. This is not an indigenous food to Native Americans but is a generational food."—Chef Boulds

Fry Bread (see page 96)
2 pounds ground beef or elk
2 medium yellow onions, diced
1 can kidney beans, rinsed and drained
½ can refried beans
2 tablespoons ground cumin
¼ cup water
Kosher salt and freshly ground black pepper
1 pound shredded cheddar cheese
1½ to 2 cups tomatoes, diced
Medium head of romaine lettuce, chopped
Sour cream
Salsa

Prepare the Fry Bread the night before or 4 to 5 hours before your meal.

Brown ground meat with 1 chopped onion in skillet over medium-high heat. Drain any fat if using ground beef (elk will have little to no fat and won't need to be drained). Add both beans, cumin and water. Mix thoroughly with meat, and add salt and pepper to taste. Remove from heat. Spread meat over Fry Bread and garnish with your favorite topping: cheese, onions, tomatoes, lettuce, sour cream, salsa, etc. Meat mixture can be made while the Fry Bread is rising or the day before; just reheat before serving.

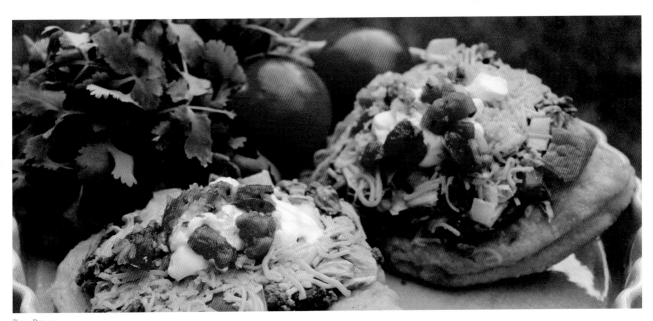

Jean Petersen.

STUFFED PORTERHOUSE PORK CHOP
with PEPPERCORN SAUCE

SERVES 4

"THE BRINE AND PEPPERCORNS MAKE THIS DISH. ADDED WITH THE BACON AND SOFT CHEESE, THE INGREDIENTS COME TOGETHER TO BE SWEET AND SAVORY, WHICH ADDS A LITTLE EXTRA SURPRISE FLAVOR IN THE STUFFING. I ALWAYS SELECT A PORK CHOP AT LEAST AN INCH AND A HALF TO TWO INCHES THICK. THE BRINE KEEPS THE MEAT FORK-TENDER WHEN COOKED. THIS IS AN EASY RECIPE TO MAKE A RUSTIC COOK INTO A GOURMET CHEF."—CHEF BOULDS

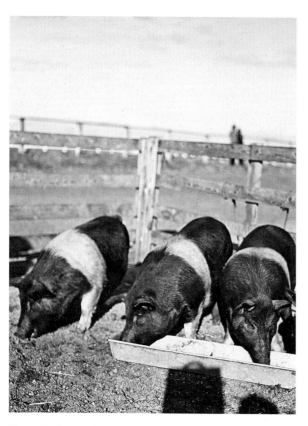

Hampshire hogs at the Montana State Fair [circa 1900–1920]. Photograph by N.A. Forsyth. *Montana Historical Society Research Center Photograph Archives, Helena, MT.*

PORK CHOP BRINE

1 quart (4 cups) hot water
8 garlic cloves, smashed
½ cup maple syrup
½ cup soy sauce
1 tablespoon balsamic vinegar
2 sprigs each of fresh rosemary,
 sage and thyme

4 pork chops, center loin or
 porterhouse, 1½ to 2 inches thick
8 ounces fontina cheese, cubed
6 bacon slices, fried limp and cut in half
Fresh sage leaves
Kosher salt and freshly ground
 black pepper

PEPPERCORN SAUCE

2 cups root beer
2 cups beef stock or store-bought
 prepared demi-glace (see page 176)
2 tablespoons drained green
 peppercorns in brine
1 tablespoon cornstarch mixed with
 equal parts cold water

Barrie Boulds.

FOR THE BRINE: *Mix brine ingredients, cool to room temperature, pour over pork chops and refrigerate overnight or up to 24 hours.*

Preheat oven to 450 degrees. Remove pork chops from the brine and pat dry. Take a sharp knife and make a slit in each pork chop, making sure the inside is opened but that the slit stays only large enough to push ingredients in. Put 2 ounces of fontina cheese in the slit and follow with 3 bacon slices. Season with salt and pepper. Grill on medium-high heat to put grill marks on each side of the chops and then place on baking sheet in oven for 15 minutes or until cheese starts oozing out. Place on plates or platter and put Peppercorn Sauce over the top. Garnish with fresh sage leaves.

FOR THE SAUCE: *Heat root beer and stock or demi-glace in a saucepan, bring to a boil, reduce heat to medium and cook sauce until reduced by half or sauce coats the back of a spoon. If the sauce needs to be thickened, add cornstarch mix. Stir in peppercorns and serve over pork chops.*

BARBERA'S RISOTTO–TRADITIONAL PIEDMONT

SERVES 8–10 ENTRÉE-SIZE DISHES

"THIS RECIPE WAS GIVEN TO ME BY MY WONDERFUL AND BEAUTIFUL FRIEND FRANCESCO DUCREY
GIORDANO FROM ITALY. IT IS HIS GRANDMOTHER'S RECIPE, AND I HAVE SLIGHTLY ADAPTED IT FROM THE
ORIGINAL. HE WAS A GUEST CHEF AT MY BISTRO ONE NIGHT AND HE MADE THIS RISOTTO. I HAD NEVER
HAD PURPLE RISOTTO BEFORE AND WAS COMPLETELY IN LOVE WITH THIS DISH WHEN FINISHED. THE
RECIPE IS LABOR INTENSIVE, BUT THE RESULTS ARE PHENOMENAL!"—CHEF BOULDS

2 quarts (8 cups) beef stock (prepared
the day before) (see page 176)

3 tablespoons Tomato Puree* (prepared
the day before)

3 beef marrow bones (ask your butcher
or use beef middle leg bones cut 3
inches thick or leg bones sliced 3
inches long)** (prepared the day
before)

1 bottle Piedmontese Barbera d'Asti red
wine (or any other red wine you really
like), 1 small glass reserved for finishing
risotto

3 tablespoons olive oil

½ cup (1 stick) unsalted butter

2 large sweet onions, peeled and sliced
very thin

1 leek, cleaned and sliced very thin, using only
the white and pale green parts

3 bay leaves

4 cups or 2 pounds white Italian rice (carnaroli,
not arborio)

1 tablespoon potato starch or all-purpose flour

Small bouquet of fresh sage

½ cup grated parmigiano-reggiano

1 teaspoon nutmeg, freshly grated

Freshly ground black pepper, to taste

*TOMATO PUREE

1 can peeled and chopped tomatoes

1 large carrot, small dice

2 teaspoons white sugar

The day before, prepare the beef stock, Tomato Puree and bone marrow.

*Heat the beef stock and red wine in separate saucepans and keep warm. In a large stainless steel
sauté pan (11x4 is ideal), heat 2 tablespoons of oil and 1 tablespoon butter over medium-low to
medium heat and add onions, leeks, bone marrow and bay leaves. Stir with a long wooden spoon until
the onions are blond and mellow. Add the rice and stir for 4 to 5 minutes to toast. Add the potato
starch and stir until just combined. Then add half of the heated red wine. Stir until it all reduces
and the rice absorbs the liquid, just short of sticking (don't let it burn; just toast it). Add the rest of
the heated red wine (keep 1 glass for the end) and add a small bouquet of fresh sage while stirring*

Barrie Boulds.

continuously. When the previous liquid is absorbed, start adding one to two ladles of stock at a time and keep cooking while stirring often, only adding more liquid when the liquid is absorbed. From time to time, check the cooking level while stirring and balance the liquid level with the heat level—not too dry and not too much liquid.

When the rice is cooked to al dente, turn down the heat to low and add all the parmesan, remaining butter, nutmeg, black pepper and the last small glass of red wine. Stir well and serve. Traditionally served in soup plates, it should still have a little liquid coating the grains (not dry) and should be eaten with a spoon rather than a fork.

FOR THE PUREE: *In a thick-bottomed pot, pour the can of tomatoes with the diced carrots and cook on medium-high until slightly thickened, being careful not to burn. Turn down to a simmer, adding sugar, and simmer covered until the liquid is evaporated. Don't burn it; you can interrupt the cooking to allow a cool-down period if needed and then resume cooking again. The puree will concentrate.*

**BONE MARROW
Preheat oven to 450 degrees. Place the marrow bones upright on an aluminum foil–lined baking sheet and roast for 15 minutes. Cool slightly, dig out the bone marrow with a small spoon and keep it in a small container until ready to use. Bring to room temperature before using.

PAN-SEARED CHICKEN BREAST

SERVES 4

"My grandma would always cook chicken when we visited as kids. She had a wood and coal stove and cooked the chicken in an old, enameled metal icebox drawer. To this day, we think the secret to her scrumptious chicken was that icebox drawer. She would cook all day, and the wonderful smells filled her house. I have yet to replicate her chicken! In this dish, the brine keeps the chicken moist throughout the searing and baking process. The combination of herbs, butter and garlic makes its own sauce in the pan."—Chef Boulds

4 bone-in, skin-on chicken breasts

1 cup (2 sticks) unsalted butter

4 garlic cloves, minced

4 sprigs each of fresh thyme, rosemary and sage

1 cup chicken stock, preferably homemade (see page 175)

CHICKEN BRINE

1 cup white sugar or honey, local preferred

½ cup kosher salt

1 quart (4 cups) hot water

4 garlic cloves, smashed

2 sprigs each of fresh rosemary, sage and thyme

Make brine (see below) and brine chicken the night before.

Preheat oven to 450 degrees. Remove chicken from brine and pat dry. Heat a large cast-iron skillet or sauté pan (do not use nonstick) to medium-high heat. Add ½ cup butter, and as soon as it has melted, add chicken breasts skin side down. Sauté chicken until skin is a dark brown color. Turn the chicken over, reduce heat to medium and place garlic and all the herbs into the pan, sauté for 2 minutes and then add ¾ cup of chicken broth. Place immediately into oven and cook for 15 minutes. Take out of oven and place over medium-high heat again. Add remaining butter and chicken stock and cook for 2 more minutes to thicken sauce. Place chicken on plates and spoon pan sauce over chicken. Garnish with fresh rosemary sprigs.

FOR THE BRINE: Dissolve sugar and salt in hot water, add rest of brine ingredients and chill completely before adding chicken. Brine chicken breasts overnight or for up to 24 hours.

Nicole O'Shea.

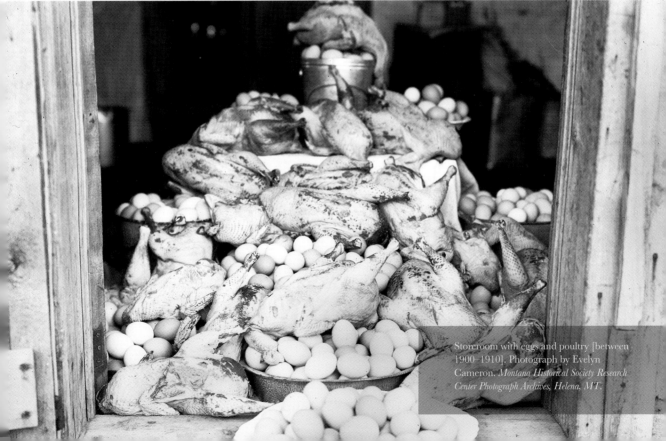

Storeroom with eggs and poultry [between 1900-1910]. Photograph by Evelyn Cameron, *Montana Historical Society Research Center Photograph Archives, Helena, MT.*

Jean Petersen.

Carbon County Fair Exhibit Hall.
Carbon County Historical Society

CARBON Co. EXHIBIT.

GARDEN VEGETABLE PESTO PASTA

SERVES 4–6

"This pasta dish is simple, and you can throw any fresh garden vegetables into it. I usually see what's available at the local farms or farmers' markets, and that dictates what's going in the pan. It's also great with sliced chicken breasts or crumbles of Italian sausage. If you want to make a quick meal under 30 minutes, this is a great recipe."—Chef Boulds

2 tablespoons (¼ stick) unsalted butter

1½ cups cremini mushrooms, sliced

4 garlic cloves, minced

½ cup sundried tomatoes, sliced thin

1½ cups artichoke hearts, rinsed and roughly chopped

¼ cup dry white wine, sauvignon blanc or pinot grigio

2 cups fresh spinach, cleaned

1 cup store-prepared pesto

12 ounces penne pasta, prepared according to package

3 ounces shredded parmesan cheese

1 lemon, quartered

Zest of 1 lemon

In a large skillet over medium-high heat, melt butter and add mushrooms. Sauté mushrooms for 2 minutes and then add garlic, sundried tomatoes and artichokes. Sauté another 2 minutes and add wine and spinach. Mix together with pesto and toss with penne pasta. Top with shredded parmesan and lemon zest and squeeze fresh lemon over pasta dish.

MONTANA ORGANIC FLAT IRON STEAK
with PEPPERED MUSHROOMS

SERVES 4

"BEING BORN AND RAISED IN MONTANA, WE KNOW OUR CUTS OF BEEF. THIS IS ANOTHER ONE OF MY
FAVORITE CUTS OF MEAT: THE FLAT IRON! IT IS ALMOST AS TENDER AS THE FILET AND MORE FLAVORFUL.
THE PEPPERED MUSHROOMS COMPLEMENT THIS STEAK WONDERFULLY!"—CHEF BOULDS

4 8-ounce Montana organic flat iron steaks
 at room temperature
Olive oil
Kosher salt and freshly ground black
 pepper

PEPPERED MUSHROOMS

¾ cup (1¼ sticks) unsalted butter
3 tablespoons freshly cracked black
 peppercorns (crack in grinder or put in
 aluminum foil and crack with smooth
 side of meat mallet)
1½ pounds cleaned and thick sliced
 mushrooms, any kind or combination,
 preferably local to your region
4 teaspoons Worcestershire
1½ teaspoons balsamic vinegar

Bring a cast-iron skillet to medium-high heat. Oil the steak and sprinkle each side with salt and pepper. Cook steaks for 2 to 3 minutes on each side. Move to platter, cover with tented aluminum foil and let rest. While the steaks are resting, make Peppered Mushrooms.

FOR THE MUSHROOMS: Heat 4 tablespoons (½ stick) butter in a pan on medium-high and add pepper and mushrooms. Sauté mushrooms until just wilted. Add Worcestershire, balsamic vinegar and remaining butter. Cook until just bubbling. Remove from heat and divide among steaks.

Chef's note: Organic, grass-fed steaks cook faster than corn fed; be careful not to overcook.

Barrie Boulds.

RIBEYE STEAK *with* GORGONZOLA BUTTER

SERVES 4

"THE MOST FLAVORFUL STEAK IS THE RIBEYE! I LIKE MY RIBEYES SIMPLY GRILLED WITH A LITTLE BLEU CHEESE BUTTER AND NOTHING ELSE. THE FLAVOR IS SO GOOD IN THIS CUT OF MEAT YOU REALLY DON'T WANT TO MARINATE OR SEASON IT. THIS IS A BEAUTIFULLY MARBLED CUT OF BEEF, AND IT CAN STAND ALL ON ITS OWN."—CHEF BOULDS

Kosher salt and freshly ground
 black pepper
4 14-ounce (1 to 1½ inches thick)
 ribeye steaks at room temperature
 (do not trim fat)
Olive oil
Gorgonzola Butter*

*GORGONZOLA BUTTER
½ cup (1 stick) unsalted butter, room
 temperature
4 ounces gorgonzola, room temperature

Preheat a grill to high heat or a large cast-iron skillet to medium-high heat. Salt and pepper each side of ribeye, and oil the grill or pan with a little olive oil before cooking. Place steaks on grill or in skillet and cook for 4 minutes per side. If grilling, move steak after 2 minutes to opposite direction on same side to make cross-hatch grill marks, pointing the steak at ten o'clock and two o'clock. Turn over after 4 minutes. Repeat process. To make sure it's medium-rare, after you turn over, push fingertip into steak. If blood wells up and does not run off steak, it is medium-rare. Top with Gorgonzola Butter.

FOR THE BUTTER: *This can be made a day ahead. Mix room-temperature butter and cheese in food processor or by hand in a bowl. Place in plastic wrap or wax paper and form a log. Place in freezer to harden up. An hour before grilling steak, remove butter from freezer and place in fridge. When ready to serve steak, remove from fridge, cut into ½- to 1-inch rounds and place on top of ribeyes.*

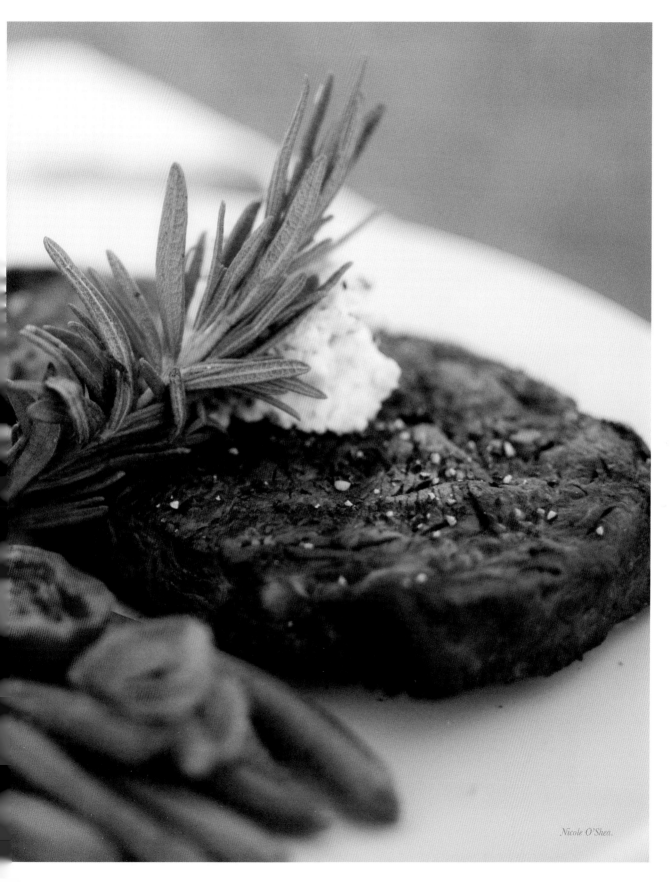

Nicole O'Shea.

Jean Petersen.

Surveyors catching trout on the B and W Trail in the Beartooth Mountains. *Carbon County Historical Society*.

PAN-FRIED TROUT

SERVES 4

"BESIDES WALLEYE, TROUT IS ONE OF MY FAVORITE FISH IN MONTANA. THERE'S SIMPLY NOTHING BETTER THAN A FRESH TROUT PULLED FROM THE RIVER. I GREW UP NEXT TO THE POPLAR RIVER, WHICH IS A TRIBUTARY OF THE MISSOURI RIVER, AND FRESH FISH WERE ABUNDANT WHEN I WAS GROWING UP."
—CHEF BOULDS

1 cup all-purpose flour

¼ cup cornmeal

1 tablespoon kosher salt

1 tablespoon freshly ground black pepper

4 8- to 10-ounce trout, filleted with skin on one side

1 cup (2 sticks) unsalted butter

2 lemons, zested and quartered

Mix flour, cornmeal, salt and pepper in shallow bowl or plate. Dredge trout in flour mixture. Shake off excess flour. Heat cast-iron skillet to medium-high heat and add ¼ cup (½ stick) of butter. Right before the butter begins to smoke, add the trout, skin side up, to skillet. Pan fry trout for 4 to 5 minutes. Be careful to turn trout over and sauté on skin side until crisp, another 2 minutes. Immediately remove trout from skillet, place on plate and pour browned butter over the top of the trout (skinless side up). Repeat with remaining trout and garnish with lemon zest and squeeze fresh lemon on top of trout. Serve with remaining lemon wedges.

CORNED BEEF BRISKET *with* HASH

SERVES 6–8

"BEING IRISH, EVER SINCE I CAN REMEMBER, I'VE BEEN EATING CORNED BEEF AND CABBAGE ONCE A YEAR ON ST. PATRICK'S DAY. WELL, ONE YEAR, I DECIDED THE 'SAME OLD THING' WAS GETTING OLD, SO I DECIDED TO START A NEW TRADITION AND BEGAN MAKING CORNED BEEF HASH INSTEAD. I'VE NEVER LOOKED BACK!"—CHEF BOULDS

3 pounds fatty, flat-cut brisket

4 quarts (16 cups) water

2 bay leaves

2 teaspoons peppercorns

4 allspice berries

2 whole garlic cloves

½ large green cabbage (about 2 pounds), cut into wedges

16 small new red potatoes (about 1¼ pounds), halved

HASH INSTRUCTIONS

1½ medium yellow onions, grated

4 cloves garlic, grated

¼ cup whole grain mustard

½ tablespoon thyme

1 tablespoon nutmeg, freshly grated

Ground pepper to taste

1 parsley bunch

From Corned Beef Leftovers, Combine:

2 cups boiled potatoes, smashed

2 cups cooked cabbage, cut up

¾ cup cooking liquid from cooked corned beef

Pulled corned beef

Unsalted butter for frying

Preheat oven to 300 degrees. Rinse brisket, place in Dutch oven and add all ingredients except cabbage and potatoes. Bring to a boil uncovered, then cover and transfer to oven. Braise until tender, about 3 to 3½ hours.

Take brisket out and tent with aluminum foil. While brisket rests, add cabbage and potatoes to cooking liquid in Dutch oven and bring to a boil on stove top, then simmer for 15 minutes.

FOR THE HASH: *Combine all ingredients, adjusting liquid and ingredients to taste, and grill in hot butter until browned on both sides.*

Barrie Boulds.

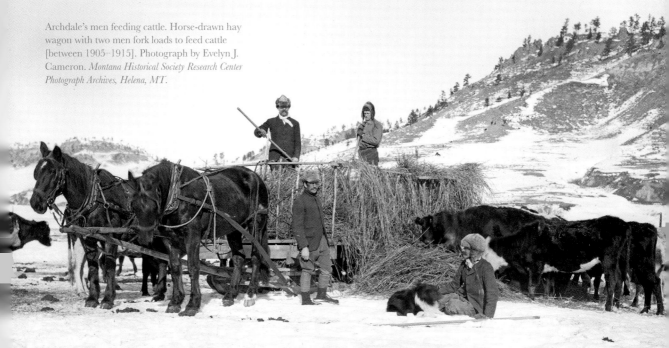

Archdale's men feeding cattle. Horse-drawn hay wagon with two men fork loads to feed cattle [between 1905–1915]. Photograph by Evelyn J. Cameron. *Montana Historical Society Research Center Photograph Archives, Helena, MT.*

WIGLI UN KAGAPI (FRY BREAD)

MAKES 16–20 LARGE FRY BREAD (THIS RECIPE CAN BE HALVED!)

"THIS RECIPE IS FROM JUNE SHY FACE, WHOM I WORKED WITH AT A CAFÉ IN POPLAR ON THE RESERVATION GROWING UP. SHE WAS NATIVE AMERICAN AND TOLD ME I COULD NEVER GIVE OUT THE RECIPE UNTIL SHE PASSED AWAY. EVERYONE HAS A GRANDMA, AUNTIE OR COUSIN WHO MAKES 'THE BEST' FRY BREAD. I LIKE JUNE'S RECIPE BECAUSE OF THE ADDED YEAST. EVERY EVENT OR PARTY I ATTEND, I AM ALWAYS ASKED TO BRING THIS DISH."—CHEF BOULDS

5 cups warm water

5 tablespoons regular active dry yeast

5 tablespoons white sugar

5 dashes salt

5 tablespoons vegetable oil or
 canola oil

4 eggs

8 cups all-purpose flour

½ gallon oil (canola, vegetable or lard/
 Crisco)

Barrie Boulds.

Put 5 cups of very warm water in a large bowl. Add 5 tablespoons yeast and 5 tablespoons sugar. Cover and let yeast start to bubble, about 10 minutes. Once yeast is ready, add salt and oil and whisk in eggs one by one until incorporated. Add flour with a wooden spoon, 2 cups at a time. You will use more or less 6 cups, adding or subtracting to get a sticky dough. Place in warm area.

Let dough rise and double in size for 1 to 1½ hours, punch down and let rise again. Add enough flour, about 2 more cups, to make a very soft dough; do not overwork. The dough should be soft and easy to spread out by hand. Pinch off enough dough to roll out to make a 6- or 7-inch circle. Put two slits in the dough and drop into hot oil, two pieces at a time. You can make smaller bread; just put one slit in the top. Do not overcrowd. When side facing down turns a deep golden brown, turn it over and finish on other side. Drain on paper towels. Serve with confectioner's sugar and butter or use to make Indian Tacos. Store in Ziploc bags with paper towels up to 3 days.

Nicole O'Shea.

ORGANIC QUICHE IN PERFECT PIE CRUST

SERVES 4-6

"I REALLY LIKE MAKING QUICHE. IT REMINDS ME OF HOW LUCKY I AM THAT I CAN GET FRESH PRODUCE, FARM-FRESH EGGS AND MILK LOCALLY FROM LOCAL FARMS AND FARMERS' MARKETS. THERE'S NOTHING COMPARED TO THE TASTE OF FARM-FRESH EGGS AND CREAM. THE EGG-TO-CREAM RATIO MIGHT SEEM OFF IN THE RECIPE, BUT IT MAKES THE QUICHE VERY FLUFFY AND CREAMY. I THINK IT'S A PERFECT BALANCE OF EVERYTHING FRESH AND GOOD!"—CHEF BOULDS

6 eggs

Kosher salt and freshly ground black pepper, to taste

3 cups half-and-half

3 ounces Swiss cheese, or your cheese of choice

¼ cup chopped onions

½ cup packed spinach leaves

½ cup sliced mushrooms

¼ cup sundried tomatoes

Perfect Pie Crust (see page 161)

Preheat oven to 350 degrees. Mix eggs, salt, pepper and half-and-half thoroughly. Put cheese and veggies into the bottom of the pie crust, starting with cheese, onion and then spinach, followed by the rest of the ingredients. Pour egg mixture into pie crust and bake for 40 to 60 minutes.

FARM-FRESH FRITTATA

SERVES 6–8

"Frittata is a great brunch dish, and I love to
serve it with fresh tomatoes, basil and feta
cheese on top. I like to serve it alongside fresh
fruit drizzled with local honey and dill or
mint."—Chef Boulds

1 dozen farm-fresh eggs

1 cup half-and-half or milk

Kosher salt and freshly ground black pepper, to taste

2 sliced scallions, white and green parts only

½ cup red onions, sliced

½ red pepper, sliced lengthwise and seeds removed

½ yellow pepper, sliced lengthwise and
 seeds removed

¼ cup sundried tomatoes

1 tablespoon olive oil

1 large heirloom tomato, diced

Fresh torn basil leaves

Crumbled feta (optional)

*Preheat oven to 425 degrees. Mix the eggs and half-
and-half thoroughly together with salt and pepper.
Heat 10-inch cast-iron skillet or oven-proof sauté
pan to medium-low heat and sauté both onions,
both peppers and sundried tomatoes in the oil for 2
minutes. Add the egg mixture and cook on the stove
top for 2 minutes without stirring. Put the frittata in
the oven and bake for 20 minutes, until the middle is
set and the eggs puff a little on top. Remove from the
oven and let it cool slightly, then invert it onto a round
platter and cut into wedges. Top with diced tomatoes,
basil and feta.*

Barrie Boulds.

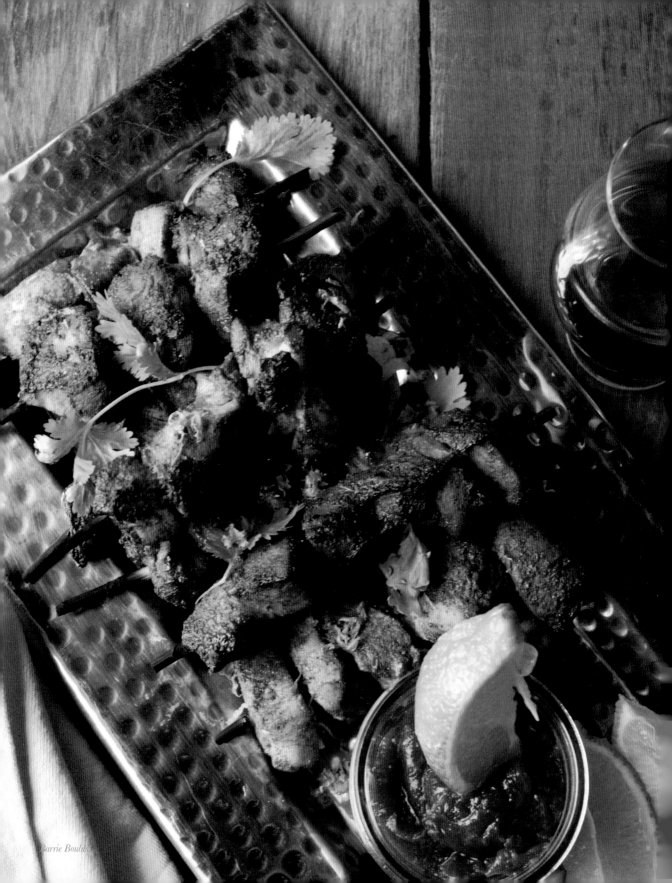

Barrie Boulds

THAI CURRY CHICKEN SKEWERS *with* DIPPING SAUCE

SERVES 8-12

"It's really hard to get any kind of Thai food in Montana. I love Thai food, so I like to combine different Thai regional flavors when ingredients are hard to come by or replicate. It's like getting the best flavors of Thailand in one dish."—Chef Boulds

Wooden skewers, soaked in water overnight

½ teaspoon olive oil

1 teaspoon fish sauce

1½ teaspoons ground coriander

¼ cup soy sauce

3 tablespoons brown sugar

1 lime (zest and juice)

3 garlic cloves

2 tablespoons vegetable oil

1 tablespoon yellow curry

½ teaspoon ground ginger

¼ teaspoon ground cardamom

½ teaspoon salt

1/8 teaspoon dried Thai chili peppers (do not touch, wear gloves; these can be substituted with 1 teaspoon crushed red pepper)

4 to 6 boneless, skinless chicken breasts cut into 1½-inch cubes

1 cup freshly picked cilantro for garnish

DIPPING SAUCE

13.5-ounce can of coconut milk

½ cup peanut butter

1/3 cup brown sugar

1½ tablespoons soy sauce

1 tablespoon red curry paste

3 tablespoons lime juice

Combine all the ingredients except cilantro and add chicken. Marinate in the refrigerator overnight for the flavors to develop. Thread the chicken onto skewers (wear gloves) and grill on a medium-high grill on all sides, being careful not to burn sugars in marinade, until the chicken is cooked through. Garnish the chicken skewers with cilantro and serve with the dipping sauce.

FOR THE SAUCE: *Combine ingredients, mix until smooth and serve with chicken skewers. The dipping sauce can be made the night before.*

Jean Petersen

PART IV. WILD GAME ENTRÉES

WE CAN SEND OUT AT ANY TIME AND OBTAIN
WHATEVER SPECIES OF MEAT THE COUNTRY AFFORDS
IN AS LARGE QUANTITY AS WE WISH.

—Captain Meriwether Lewis, referring to buffalo, antelope, deer, elk and bear near the Milk River on May 8, 1804. The Milk River is located in the northeast portion of Montana, close to Alberta, Canada. It is a tributary of the Missouri River and ends a bit east of Fort Peck, Montana.

Jean Petersen.

ANTELOPE CHOPS *with* CHIMICHURRI SAUCE

SERVES 4–6

"THERE ARE NO REAL ANTELOPE IN NORTH AMERICA. THEY ARE ACTUALLY PRONGHORNS, A DISTANT RELATIVE TO THE GIRAFFE, AND NO RELATION TO THE ANTELOPE SPECIES IN AFRICA. PRONGHORNS ARE UNIQUE TO NORTH AMERICA BUT ARE OFTEN CALLED ANTELOPE IN NORTH AMERICA."—CHEF BOULDS

6 6- to 8-ounce bone-in antelope chops
 or sirloin steaks
Chimichurri Sauce*
Kosher salt and freshly ground black pepper

*CHIMICHURRI SAUCE

1 bunch garden-fresh Italian parsley, stems
 removed and roughly chopped
½ cup garden-fresh cilantro
⅓ cup red wine vinegar
3 garlic cloves, minced
½ teaspoon dried crushed red pepper
½ teaspoon ground cumin
½ teaspoon kosher salt
½ cup extra virgin olive oil

FOR THE SAUCE: *Combine all chimichurri ingredients in a blender and pulse a few times until combined and thickened. Pour half of the sauce over the antelope in a glass pan to marinate, reserving the other half for later use. Marinate the antelope for at least 1 hour or up to overnight.*

Preheat grill or cast-iron skillet to medium high. Remove antelope from sauce, shaking off extra sauce, and season with salt and pepper. Grill antelope 2 to 3 minutes per side to medium-rare or medium. Spoon remaining Chimichurri Sauce across the meat before serving.

7A-H1627

37700K BULL ELK, TOWER FALL AREA COPYRIGHT BY HAYNES INC., YELLOWSTONE PARK, WYO.

Haynes postcard No. 3700K, Bull Elk, 1935, Tower Fall Area. F. Jay Haynes photo. *Yellowstone Historic Center Collections.*

Frank J. Haynes, an entrepreneurial photographer from Minnesota, journeyed out west after a fortuitous meeting with a railway superintendent. Young Haynes was commissioned in 1875 by the Northern Pacific Railroad to photograph promotional pictures featuring the expansion of the rail line from Minnesota to the West Coast. During his tours through the West, he was the first photographer to photograph Yellowstone National Park in the winter of 1887 on a two-hundred-mile, twenty-nine-day ski and snowshoe trek. Haynes became known as the "Official Park Photographer." He played a major role in documenting the first glimpses of the park and the western landscapes as they developed. Haynes began producing his photo postcards, called "penny postals," in 1897. He used a technique to hand tint them by painting the photos and turned them into mailable cards. These postcards were produced from 1900 until 1940, even after Haynes' death in 1921, by his son Jack, who took over the family business. By this time, the Haynes family had thirteen photo studios. Jack, too, had a treasured kinship with the park and was known as "Mr. Yellowstone." Haynes collectable souvenir photographs, postcards and official guidebook of the park remained in print until the late 1960s. The Haynes photo postcards were seen around the world and are said to have helped Yellowstone National Park expand its international presence by promoting these western landscapes.

ELK TENDERLOIN *with* HUCKLEBERRY DEMI-GLACE

SERVES 4

"ELK IS A QUINTESSENTIAL NATIVE NATURAL MEAT. IT HAS SUCH A QUALITY TO ITS MEAT AND FLAVOR. TYPICALLY, ELK IS NOT TOO GAMEY OF A MEAT AND IS LIKE BUTTER ON YOUR FORK WHEN COOKED RIGHT. THE JUNIPER BERRIES COMPLEMENT THE ELK, AND HUCKLEBERRIES ARE NATIVE TO OUR STATE. THIS IS A THROUGH-AND-THROUGH MONTANA DISH."—CHEF BOULDS

4 6- to 8-ounce elk tenderloin filets,
 at room temperature
Kosher salt and freshly ground black pepper
1 tablespoon ground juniper berries
2 tablespoons extra virgin olive oil
2 tablespoons unsalted butter

HUCKLEBERRY DEMI-GLACE

3 teaspoons extra virgin olive oil
1 shallot, roughly chopped
1 garlic clove, crushed
2 cups prepared, store-bought demi-glace
½ tablespoon black peppercorns
1¼ cups merlot or port wine
2 fresh thyme sprigs
¾ cup huckleberries (can also substitute
 with huckleberry jam)
2 tablespoons (¼ stick) unsalted butter

FRIED CARROTS

Canola oil
1 carrot, peeled in long strips

Preheat oven to 450 degrees. Season each side of the elk tenderloin filets with salt and pepper and dust with juniper berries. Heat a cast-iron skillet over medium-high heat with olive oil and butter and sear tenderloins for 2 to 3 minutes on each side, then place in oven for 5 minutes. Remove from oven and let rest another 8 minutes. Place on plates and top with Huckleberry Demi-glace and Fried Carrots.

FOR THE DEMI-GLACE: Heat a medium-sized saucepan with oil and sauté shallots and garlic until translucent. Add demi-glace, peppercorns, wine and thyme sprigs. Bring to a boil, turn down to simmer and reduce to half. Strain liquid through fine mesh sieve or cheesecloth. Discard herbs and vegetables. Return liquid to heat, add huckleberries and reheat. Remove from heat and add butter. Stir until just incorporated.

FOR THE CARROTS: Heat an inch of oil in a small pan to about 350 degrees. Add a few carrot peels at a time, careful not to crowd, and fry until slightly curled up but not browned; this only takes a few seconds. Drain on paper towels.

Barrie Boulds.

BEAVER POT ROAST *with* ROOT VEGETABLES AND WILD GARLIC

SERVES 6–8

"A KEY TIP IN PREPARING BEAVER MEAT IS THAT IT MUST BE CLEANED AND SOAKED OVERNIGHT IN SALT WATER (RATIO 2 TABLESPOONS TO EVERY 4 CUPS OF WATER). THE NEXT DAY, REMOVE THE MEAT AND RINSE IT OFF WITH CLEAN WATER. PUT THE BEAVER IN A SOUP POT AND COVER WITH A WEAK SOLUTION OF BAKING SODA AND WATER (1 TEASPOON SODA TO 1 QUART [4 CUPS] WATER). BRING IT TO A BOIL AND BOIL FOR 10 MINUTES. REMOVE AND PAT DRY. THIS IS DONE TO CLEAN AND TAKE AWAY THE GAMEY TASTE."
—CHEF BOULDS

1 3- to 4-pound beaver hindquarter roast, salt and peppered (can be substituted with beef chuck roast)

3 tablespoons extra virgin olive oil

1 cup dry red wine, preferably cabernet

½ cup yellow onions

1 large parsnip, peeled and roughly cut into large pieces

3 celery ribs, roughly cut into large pieces

2 carrots, roughly chopped

1½ cups baby red potatoes, halved

2 medium yellow onions, quartered

Small bunch of wild garlic, cleaned, white part and bulb only (reserve green parts for garnish)

3 tablespoons unsalted butter

3 tablespoons all-purpose flour

3 cups beef stock (see page 176)

3 tablespoons balsamic vinegar

Bouquet of thyme, rosemary and sage

2 bay leaves

Preheat oven to 350 degrees. Over medium-high heat in a Dutch oven or large pot, sear beaver roast on all sides in a little oil. Remove from pan and set aside. Deglaze pan with ½ cup wine, scraping up any stuck bits off the bottom of the pot, and reserve sauce with roast.

Using the same pan, wipe clean, add a little more oil and sauté vegetables until lightly browned. Add butter, sprinkle flour over the vegetables and stir until flour is lightly browned. Add remaining wine, stock, balsamic vinegar, herb bouquet and bay leaves. Bring to simmer and add meat and reserved sauce. Cover with parchment paper and make complete seal with aluminum foil and put lid on pot. Place in oven and bake for 1½ to 2 hours. Cook until it is fall-apart tender. Garnish with wild garlic.

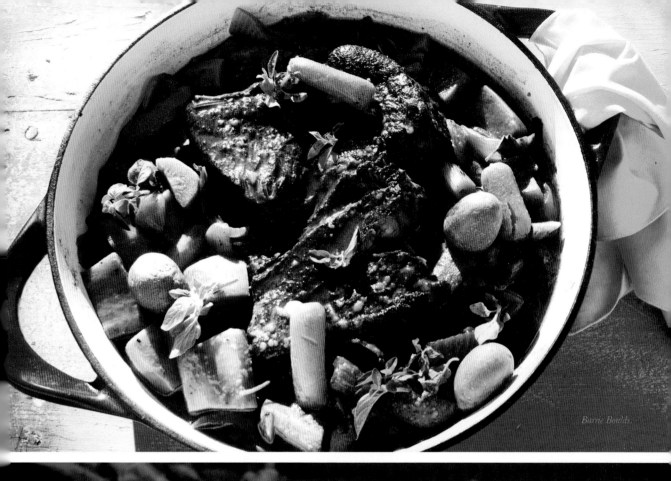

Barrie Boulds.

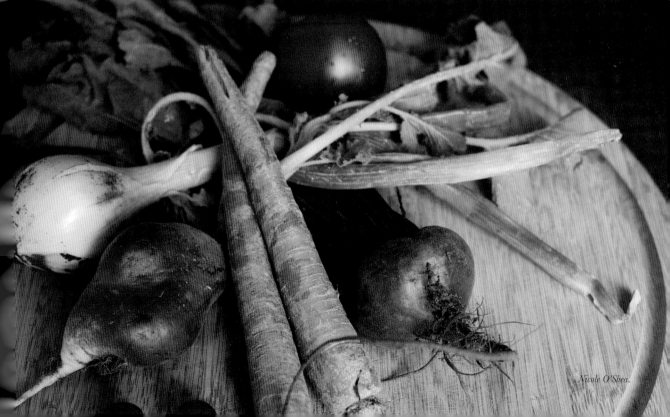

Nicole O'Shea.

ELK CHILI *with* NATIVE AMERICAN GABOO BOO BREAD

SERVES 8–12

"GROUND ELK IS GREAT FOR CHILI. YOU DON'T HAVE TO DRAIN THE FAT BECAUSE THE FAT CONTENT IS SO LOW!"—CHEF BOULDS

1 tablespoon olive oil

2 pounds ground elk

1 large onion, diced

2 celery stalks, diced

2 teaspoons cayenne pepper

1 tablespoon ground cumin

1 tablespoon chili powder

1 can (15.5 ounces) red kidney beans, rinsed and drained

1 can (15.5 ounces) chili beans

1 can (15.5 ounces) red beans, rinsed and drained

1 can (28 ounces) whole tomatoes, with juice, crushed by hand

1 small jar (about 8 ounces) of your favorite salsa

¼ to ½ cup grape jelly

3 to 5 cups of water (or to whatever consistency of chili you want)

Kosher salt and freshly ground black pepper

Heat the oil in a large pot or Dutch oven over medium-high and add elk, onion and celery. Sauté until meat has browned and the vegetables are soft, about 10 minutes. Add the cayenne, ground cumin and chili powder and stir for 1 minute. Add the rest of the ingredients, bring to a boil and immediately turn down to low, partially covered, and simmer for 30 to 40 minutes. Season with salt and pepper.

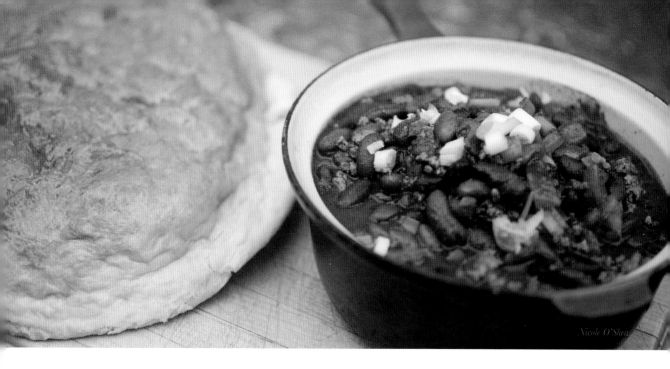

Nicole O'Shea

GABOO BOO BREAD

"This recipe comes from the Trottier family, descended from the Turtle Mountain Band of
Chippewa Indians. When the Native Americans would receive their commodities and rations
from the government, this was one of the many variations of these staple breads they
would make with them. Fry bread, Navajo bread, gaboo boo bread, bannock, gullet bread...
there are endless regional names and variations of this bread, and each tribe and Native
American family has its own special recipe. It can be served alone or with soups such as
stews, wojapi or chili."—Chef Boulds

2 eggs
1 cup warm whole milk
¼ cup warm water
5 cups all-purpose flour
5 tablespoons baking powder
1 cup white sugar
1 tablespoon unsalted butter, melted

Preheat oven to 300 degrees. In a large glass bowl, crack the 2 eggs and add the cup of warm milk and ¼ cup of warm water. Mix well. In another bowl, add all dry ingredients. Pour liquid over flour mix until a soft dough forms. Knead for 2 minutes on a floured surface. Lay bread on a flat baking sheet and form it into a 7x10 loaf. The bread should be flat. Bake for 40 minutes. For the last 5 minutes, raise the oven temperature to 350 degrees and brush with melted butter.

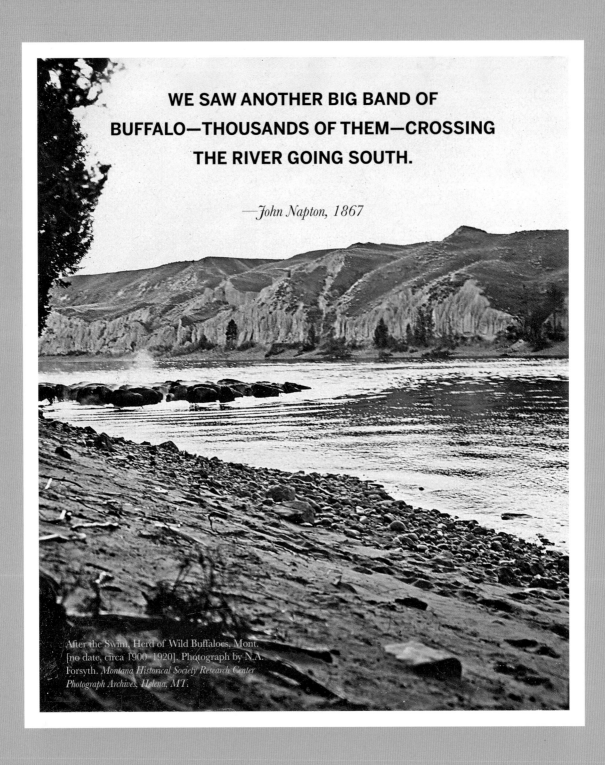

WE SAW ANOTHER BIG BAND OF BUFFALO—THOUSANDS OF THEM—CROSSING THE RIVER GOING SOUTH.

—*John Napton, 1867*

After the Swim, Herd of Wild Buffaloes, Mont. [no date, circa 1900–1920]. Photograph by N.A. Forsyth. *Montana Historical Society Research Center Photograph Archives, Helena, MT.*

Barrie Boulds.

BRAISED BISON BACK RIBS

SERVES 6-8

"THIS IS A MORE HERB- AND EARTHY-FLAVORED DISH RATHER THAN THE TRADITIONAL SWEET AND TANGY RIB. THIS HAS A HINT OF A STEW TASTE, SO IT COMPLEMENTS THE FLAVOR OF THE BISON AND DOES NOT TAKE IT AWAY LIKE SOME OTHER BARBECUE SAUCES."—CHEF BOULDS

Vegetable or canola oil, to coat pan
5 pounds bone-in bison ribs
3 medium yellow onions, chopped
3 large carrots, peeled and chopped
3 celery stalks, chopped
3 garlic cloves, smashed and diced
¼ cup all-purpose flour
2 tablespoons tomato paste
1 bottle dry red wine, preferably cabernet
1 bunch of thyme, oregano, rosemary, and parsley tied together
Kosher salt and freshly ground black pepper

Preheat oven to 350 degrees. Heat oil in a large Dutch oven over medium-high heat. Salt and pepper bison ribs and brown on both sides in pan. Transfer to plate and set aside. Add some more oil and sauté onions, carrots, celery and garlic. Sauté for 5 minutes. Add flour and tomato paste and cook until a deep red color. Add all the red wine and add ribs back to Dutch oven. Bring to a boil and simmer for 25 minutes. Stir in bouquet of herbs and place in oven for 2 to 2½ hours, until meat is falling off the bones. Transfer meat to platter and strain liquid from Dutch oven. Skim fat off liquid and discard. Garnish with fresh herbs and serve over mashed potatoes with leftover sauces.

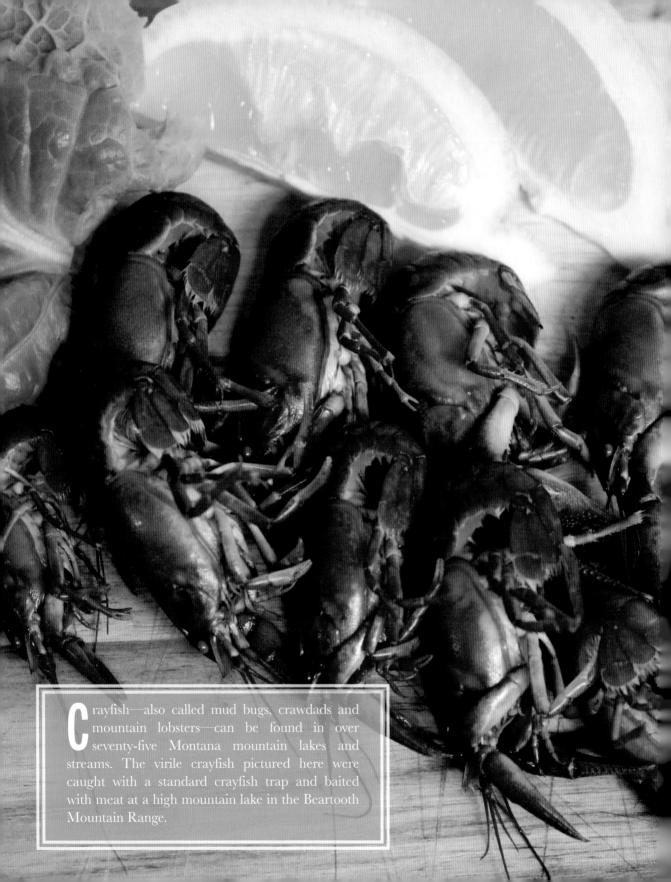

rayfish—also called mud bugs, crawdads and mountain lobsters—can be found in over seventy-five Montana mountain lakes and streams. The virile crayfish pictured here were caught with a standard crayfish trap and baited with meat at a high mountain lake in the Beartooth Mountain Range.

GRANDMOTHER RACICOT'S CRAYFISH

SERVES 6–8

"THIS RECIPE CAME FROM OUR MOTHER'S MOM, WHO LIVED IN THOMPSON FALLS. THEY OWNED A RANCH ON THE CLARK FORK RIVER. CRAYFISH WERE VERY PLENTIFUL IN THE RIVER, SO OUR GRANDMOTHER PUT TOGETHER A RECIPE TO PREPARE IN A TASTY SAUCE OVER COOKED RICE. IN ADDITION, OUR PARENTS HAD A CABIN ON MCGREGOR LAKE BETWEEN KALISPELL AND LIBBY FOR MANY YEARS. IT WAS ALSO VERY PLENTIFUL WITH CRAYFISH, SO OUR GRANDMOTHER'S RECIPE CONTINUED TO BE ENJOYED BY HER EXTENDED FAMILY AND IS STILL TO THIS DAY."
—TIM RACICOT (2013),
BROTHER OF GOVERNOR MARC RACICOT

1 bunch scallions, chopped
½ large white onion, chopped
½ bell pepper, chopped
2 rib celery stalks, chopped
2 tablespoons olive oil
½ cup (1 stick) unsalted butter
½ can or 8 ounces chicken broth (see page 175)
1 tablespoon cornstarch
2 pinches kosher salt
2 pinches Creole seasoning
3 cups wild crayfish, cleaned tail meat

Cook vegetables in olive oil until transparent. Add butter and chicken broth. Cook on low until butter melts, then add cornstarch, salt and Creole seasoning. Add crayfish and simmer 10 minutes. Serve over cooked wild rice.

SPICY TURKEY MEATBALLS

SERVES 6–8

"THIS RECIPE IS MY DAUGHTER'S FAVORITE, AND WE HAVE TWEAKED IT THROUGHOUT THE YEARS TO GET THE PERFECT BALANCE OF FLAVORS. THIS WAS HER MOST-REQUESTED DISH FOR ME TO MAKE. IT HAS BECOME OUR TRADITIONAL CHRISTMAS DAY DINNER FOR THE PAST SEVERAL YEARS. WHEN WE WOULD COOK TOGETHER; SHE WOULD MAKE TURKEY MEATBALLS, AND I WOULD MAKE INDIAN TACOS."
—CHEF BOULDS

2 pounds ground turkey

4 garlic cloves, minced

1 small yellow onion, grated

2 large eggs

3 tablespoons ketchup

½ cup parmesan cheese, grated

¼ cup unseasoned regular bread crumbs

2 teaspoons crushed red pepper flakes

¼ cup minced fresh parsley leaves

1 teaspoon kosher salt

½ teaspoon freshly ground black pepper

½ cup golden raisins

1 cup all-purpose flour

5 eggs, lightly beaten

1½ cups unseasoned regular bread crumbs

Canola oil

Preheat oven to 350 degrees. Combine turkey, garlic, onion, eggs, ketchup, parmesan cheese, ¼ cup bread crumbs, red pepper, parsley, salt, pepper and raisins in a bowl and mix thoroughly, being careful not to overwork. Once combined, roll the mixture into large meatball-size balls. Dip each ball into the flour, then into the eggs and then into the bread crumbs. Add enough oil to cover the bottom of a large sauté pan or cast-iron skillet and heat it to medium-high heat or 325 degrees. Brown meatballs on all sides and place on paper towels to drain off the excess grease. Fry meatballs in batches, making sure not to overcrowd the pan and adding oil as necessary. Place browned meatballs on sheet pan lined with parchment paper or aluminum foil. Bake for 20 minutes or until turkey meatballs are cooked all the way through. Serve with your favorite tomato sauce.

Barrie Boulds.

"Deer—Bullard and the biggest Whttail [white-tail] buck ever weight dressed 212 lbs." [1879] Bullard with dog and rifle stands with hanging game: deer, beaver and fowl. Photograph by L.A. Huffman. *Montana Historical Society Research Center Photograph Archives, Helena, MT.*

Mule and white-tail deer are the most broadly dispersed and plentiful of Montana's big game animals. Deer were also extremely prolific during the early and mid-1800s. However, overhunting began, and toward the late 1800s, the "deer skin age" was in full swing, with hides passing as currency at grocery stores and restaurants and even quoted in the newspapers as the "country's currency." According to research by Picton and Lonner for their book *Montana's Wildlife Legacy,* "The editor of the little local paper at Libby once said that the gallant young swain who took his best girl to a dance in Libby paid the entrance fee in four deer skins." Initial conservation efforts began in 1910 to trap and transplant deer to various locations around the state, one being the National Bison Range Refuge, and the numbers began to increase through preservation and management. There are currently more than 360,000 mule deer and more than 220,000 white-tail deer across the state.

Barrie Boulds.

DEER THURINGER

SERVES 4-6

"This recipe comes from my daughter Sydney's great-grandma Lucille Lien, of Froid, Montana. Everyone loved her thuringer at gatherings, and she always had some sliced with cheese, crackers and mustard. I subbed her hamburger with deer meat because I struggle with what to do with deer burger if there's a lot in the freezer. This is a great way to use it up, and it's also a great way to make 'sausage' without the casings."—Chef Boulds

2 pounds ground deer burger from the front or back quarters, cleaned of sinew, with 10 to 20 percent fat added from beef suet (hamburger can be substituted)

¼ teaspoon pepper

¼ teaspoon garlic salt

¼ teaspoon onion salt

2 tablespoons Morton's Tender Quick Home Meat Cure

¾ cup water

1 tablespoon whole mustard seed

Mix all ingredients and let chill in fridge overnight. Preheat oven to 350 degrees. Roll into several logs and wrap in aluminum foil. Poke a few holes with a fork in the aluminum foil and put rolls on a broiler pan. Bake on broiler pan for 1 hour. Remove and let cool. Once the logs cool, remove aluminum foil and rewrap each log with plastic wrap. Can be made ahead and stored in fridge.

ROASTED SQUAB *with* GRAPES

SERVES 4

"DURING THE DEPRESSION, FOOD WAS SCARCE EVERYWHERE. THIS IS A VARIATION OF MY DAD'S RECIPE FROM HIS YOUTH, GROWING UP IN PLENTYWOOD IN EASTERN MONTANA DURING THE '30S. MY DAD AND HIS FRIENDS WOULD HUNT PIGEONS AND COOK THEM OVER AN OPEN FLAME SO THEY WEREN'T SO HUNGRY WHEN THEY WENT HOME FOR DINNER. HE HAD A SPECIAL WAY OF MAKING THIS MEAL SOUND FANCY BY TELLING US HE HAD 'SQUAB UNDER GLASS.' IT SOUNDED REFINED, WHEN ACTUALLY HE HAD JUST MADE PIGEON. THIS IS MY TWIST ON THE DISH, BRINGING A MODERN SOPHISTICATION TO ITS FLAVOR WITH THE GRAPES AND PANCETTA."—CHEF BOULDS

Kosher salt and freshly ground black pepper

4 squabs (pigeon), cleaned, rinsed and patted dry (can be substituted with Cornish game hens)

4 fresh thyme and rosemary sprigs each, chopped

¾ cup (1½ sticks) unsalted butter, room temperature

2 small lemons, cut in half

2 shallots, cut in half

Olive oil

2 cups red seedless grapes

1 sprig rosemary, chopped

8 ounces chopped pancetta, fried crisp and drained on paper towels

Preheat oven to 450 degrees. Salt and pepper the bird. Combine herbs and butter and rub inside breast, inside cavity and all over the bird. Stuff the inside cavity with remainder of herbs, one half of lemon and shallots. Repeat with additional squab. Coat bottom of a cast-iron skillet or sauté pan (do not use nonstick) with oil to medium high and brown squab on all sides until they are a rich, deep brown color. Put squab breast side up and add grapes and a fresh sprig of rosemary. Put into oven and roast uncovered for 15 to 20 minutes, until internal temperature reaches 125 degrees in the thickest part of the leg. Place on 4 plates and spoon grapes over squab. Garnish with fried pancetta.

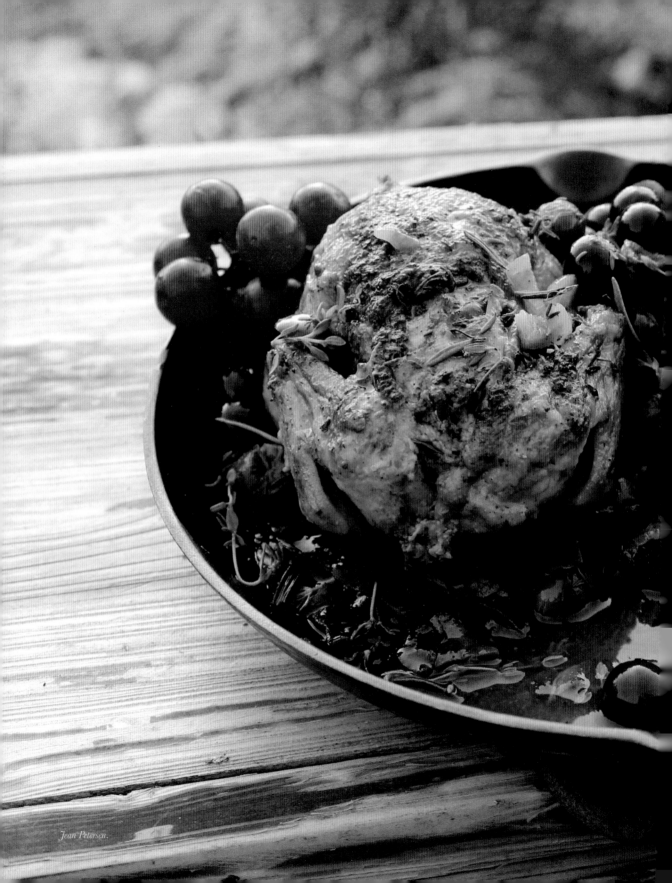

Jean Petersen.

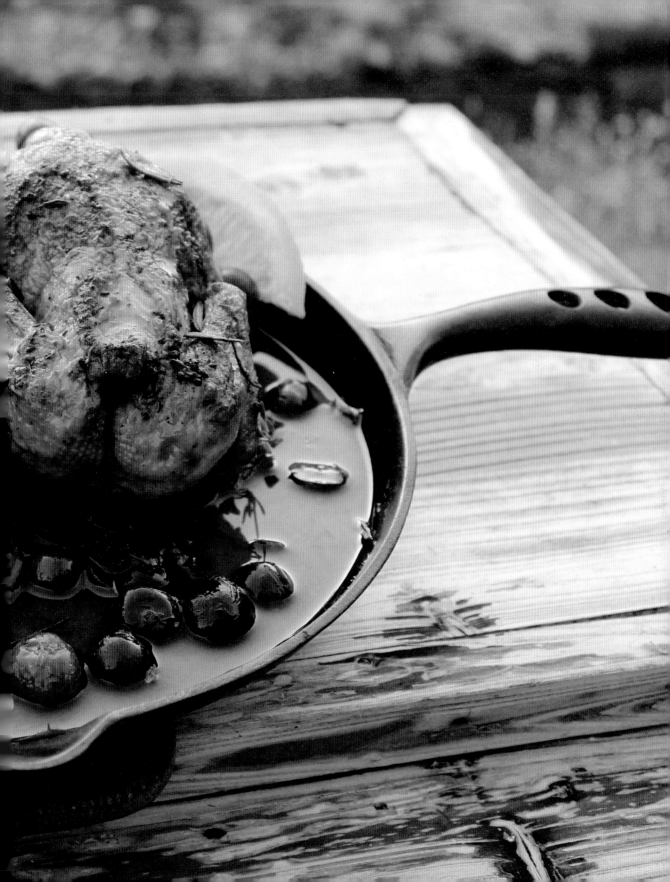

ROASTED WILD TURKEY

SERVES 4-6

"Everyone asks me what's my secret to this dish, and all I can say is the brine. I also like to use fresh turkeys from local Hutterite colonies."—Chef Boulds

10- to 15-pound whole wild turkey, brined overnight
Butter Herb Mix*
Kosher salt and freshly ground black pepper
1 cup dry white wine, preferably sauvignon blanc or pinot grigio, or chicken stock (see page 175)

TURKEY BRINE
4 cups honey or white sugar
1½ cups kosher salt
8 quarts (2 gallons) water
2 heads garlic, cut in half
3 sprigs each of fresh rosemary, sage and thyme
3 lemons, cut in half

*BUTTER HERB MIX
½ pound (2 sticks) unsalted butter, room temperature
3 sprigs each of rosemary and thyme

Dissolve honey or sugar and salt in 1 gallon of hot water. Add rest of brine ingredients and chill completely with 1 gallon of ice water before adding turkey. Remove the neck and giblets from the wild turkey. Rinse the turkey inside and out and put into brine; brine overnight.

Preheat oven to 350 degrees. Remove turkey from brine, rinse off and pat dry with paper towels. Strain brine water, reserving herbs and lemons. Slowly and carefully run fingers between breast and skin to loosen skin from breast meat. Take the Butter Herb Mix and rub under skin and all over inside and outside of turkey. Salt and pepper inside and out. Stuff turkey cavity with herb mix and a few lemon halves. Tie legs together and place wings behind turkey or cover wing tips with aluminum foil. Place in roasting pan and pour 1 cup wine or stock into the bottom of the pan to use for basting. Put into oven. Baste every ½ hour. Roast turkey for about 2½ hours, or until juices from thigh and leg run clear or a thermometer reads 160 degrees. The turkey will continue to cook to 165 degrees while resting. Take out, cover with aluminum foil and let rest for ½ hour.

FOR THE BUTTER HERB MIX: *Blend in blender until combined.*

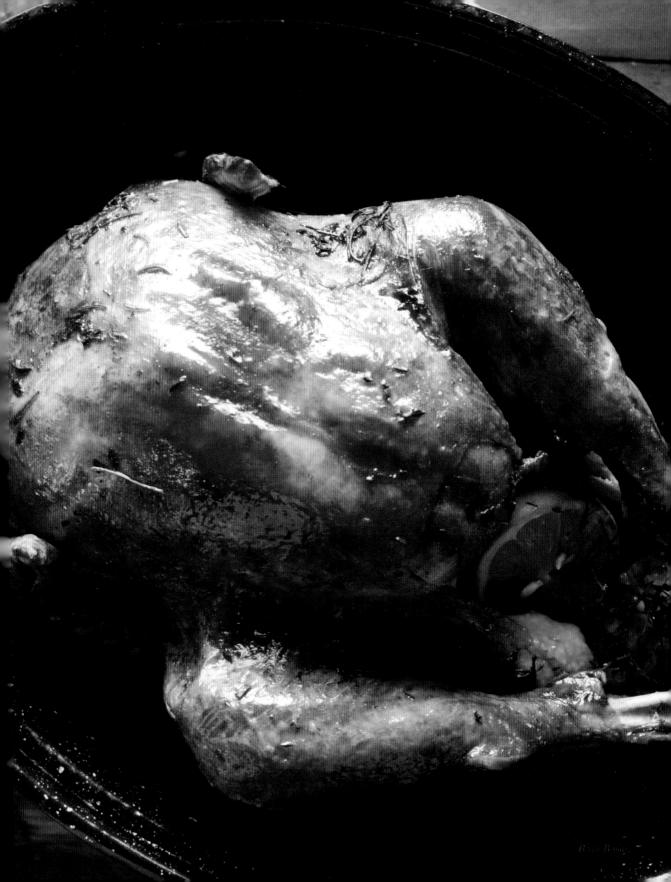

LEMON AND WILD GARLIC QUAIL OVER LINGUINI

SERVES 4

"Quail are very small birds. It takes two quail per person to make a dish. I grew up eating and hunting wild birds like pheasant, partridge and a variety of grouse in eastern Montana, where the birds are plentiful. In some parts of the country, these birds are considered a delicacy. Quail is not a native species to Montana but is a great substitution for the other wild game birds that aren't readily available for this dish."—Chef Boulds

8 quail, brined

Olive oil

½ cup chicken broth (see page 175)

1 ounce linguini, prepared according to
 directions

1 bunch wild garlic, cleaned and white parts
 chopped

¼ cup (½ stick) unsalted butter

4 lemons, zested and juiced

1¼ cups heavy cream

8 ounces parmesan, grated

Kosher salt and freshly ground black pepper

QUAIL BRINE

1 cup white sugar

½ cup kosher salt

1 quart (4 cups) water

4 smashed garlic cloves

2 lemons, cut in half

1 teaspoon whole peppercorns

To make brine, dissolve sugar and salt in hot water, add rest of brine ingredients and chill completely before adding quail. Brine the quail for about 4 hours (it does not need to be brined overnight).

Preheat oven to 400 degrees. Remove quail from brine and pat dry. Heat a Dutch oven or cast-iron pan to medium-high heat with enough olive oil to brown birds. Add quail and brown them on all sides to a dark brown. Place quail breast up, add ½ cup chicken broth to skillet and put into oven. Bake for 10 minutes in oven, then remove and let rest until ready to assemble with pasta. Lightly coat the bottom of a large frying pan with olive oil and heat on medium-high. Add wild garlic and sauté for 5 minutes. Add butter, lemon juice, half of the zest and heavy cream. Once heated through, add parmesan, stirring the whole time. Add salt and pepper to taste. Heat until thickened, then add the prepared pasta and toss until coated. Divide among four bowls and put two quail on top of the pasta. Garnish with the rest of the lemon zest.

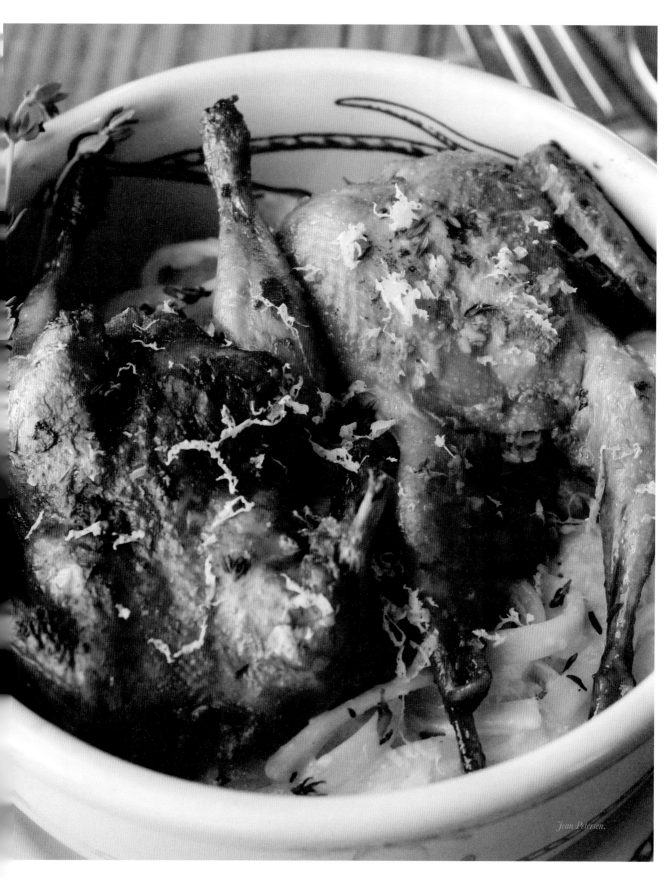

Joan Petersen.

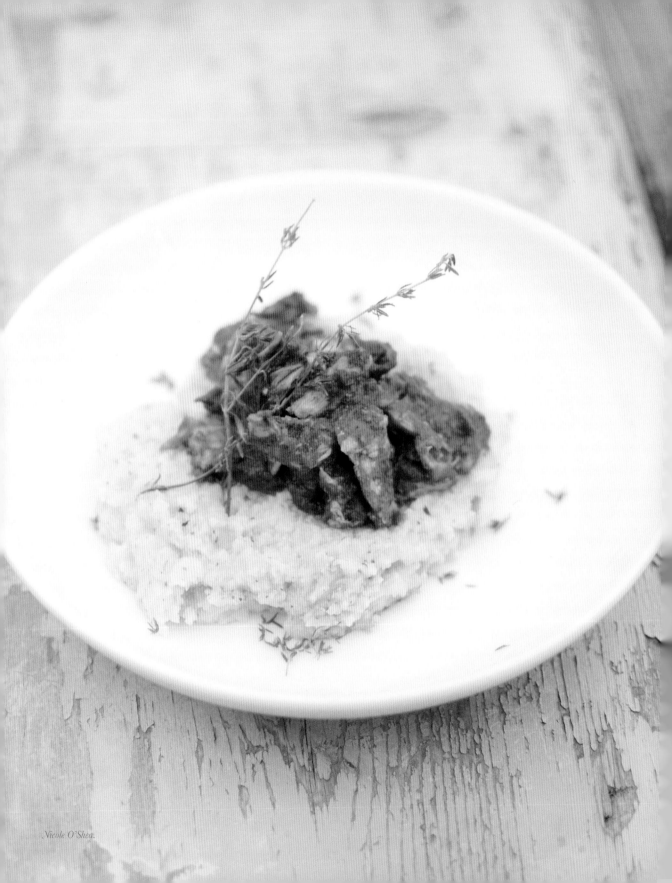

Nicole O'Shea.

RABBIT RAGU OVER PARMESAN CHEESE POLENTA

SERVES 4

"RABBIT TASTES VERY SIMILAR TO CHICKEN. MY DAD WOULD GIVE US THE LUCKY RABBIT'S FOOT AFTER A HUNT, AND I REMEMBER AS A KID THINKING THE RABBIT WASN'T SO LUCKY. THIS IS A GREAT WAY TO USE RABBIT IN A DISH IF YOU'VE NEVER TRIED IT BEFORE, BUT YOU CAN ALSO USE CHICKEN IF RABBIT IS NOT AVAILABLE."—CHEF BOULDS

1 3- to 4-pound rabbit, bone-in (rabbits can be found in specialty stores or online and will already be skinned)

Kosher salt and freshly ground black pepper

½ cup olive oil

1 large yellow onion, finely diced

2 carrots, finely diced

3 celery ribs, finely diced

2 tablespoons (5 cloves) garlic

6-ounce can tomato paste

1 cup whole milk

1 cup dry white wine, preferably sauvignon blanc or pinot grigio

2 teaspoons fresh thyme

2 bay leaves

PARMESAN CHEESE POLENTA

1 quart (4 cups) water or chicken stock (see page 175)

2 cups heavy cream

1 teaspoon kosher salt

½ teaspoon freshly ground black pepper

1¾ cups polenta

1 cup parmesan cheese

Fresh basil and parsley

Clean rabbit in cold water and cut into 8 pieces, if not already done. (Cutting up a rabbit is similar to cutting up a chicken.) Pat rabbit dry and season with salt and pepper. In a Dutch oven over medium-high heat, add ¼ cup olive oil and brown pieces of rabbit, being careful not to overcrowd, working in batches. Transfer to plate and cover with aluminum foil. Reduce heat to medium in Dutch oven and add remaining olive oil and onion, carrots, celery and garlic. Cook until translucent, about 5 to 8 minutes. Add tomato paste, milk, wine, thyme and bay leaves. Bring to a boil, reduce heat to medium low and add the rabbit pieces and cover. Simmer for 1½ to 2 hours, turning rabbit pieces halfway through process. Remove rabbit and pull meat from bones. Add rabbit meat back into the tomato mixture and season with salt and pepper to taste. Place over polenta.

FOR THE POLENTA: *Bring water or chicken stock to a boil with the heavy cream, salt and pepper in a large saucepan. Gradually whisk in the polenta and turn down the heat to medium. Continue to whisk until thickened, about another 10 to 12 minutes. Remove from heat and add ¾ cup cheese. Top the polenta with the rabbit ragu and garnish with the remaining cheese and herbs.*

PAN-SEARED MONTANA SALMON
with CILANTRO LIME SWEET CHILI SAUCE

SERVES 6-8

"Montana salmon is found in Fort Peck Reservoir, near where I grew up. We spent a lot of time over on the lake as teenagers. Many people do not know Montana has many lakes flourishing with salmon."—Chef Boulds

2 pounds Montana salmon, fileted with skin on one side
 (can substitute with any wild salmon)
Olive oil
¼ cup cilantro leaves

CILANTRO LIME SWEET CHILI SAUCE
1 cup Mae Ploy Sweet Chili Sauce
½ cup minced cilantro
1 tablespoon toasted white sesame seeds
2 limes, zested and juiced
¼ cup rice wine vinegar

FOR THE SAUCE: *Combine sweet chili sauce, cilantro, sesame seeds, zest, lime juice and rice wine vinegar and mix well. Heat over low heat until the sauce is warm. This can be made the day before and is best if you let the flavors meld for a few hours. Reheat sauce for salmon.*

Preheat oven to 500 degrees. Cut salmon into 6- to 8-ounce portions, leaving the skin intact on one side, and pat dry. Heat two 10-inch ovenproof sauté pans over medium-high heat with a splash of olive oil. Right before the oil starts smoking, add the salmon with the skin side up; do not crowd. Sauté for 3 to 4 minutes on this side only; do not touch salmon until a nice crisp crust is formed on meat. Carefully turn salmon over, immediately place into the heated oven and cook for another 5 minutes. Take salmon out of the oven and let it rest for 10 minutes. Spoon the sweet chili sauce over the top and garnish with cilantro.

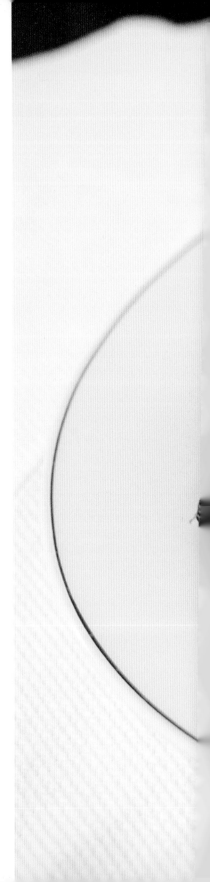

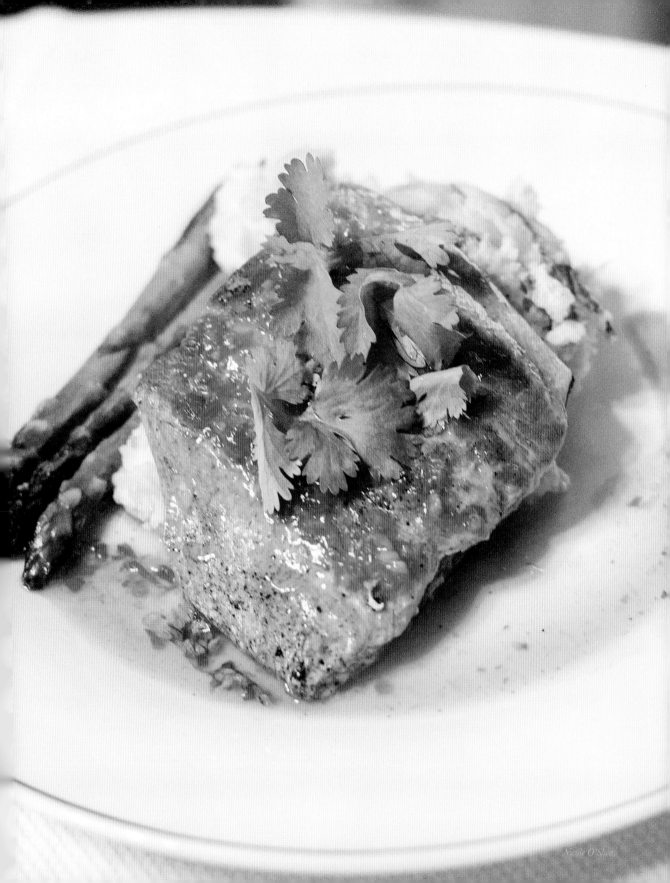

Nicole O'Shea

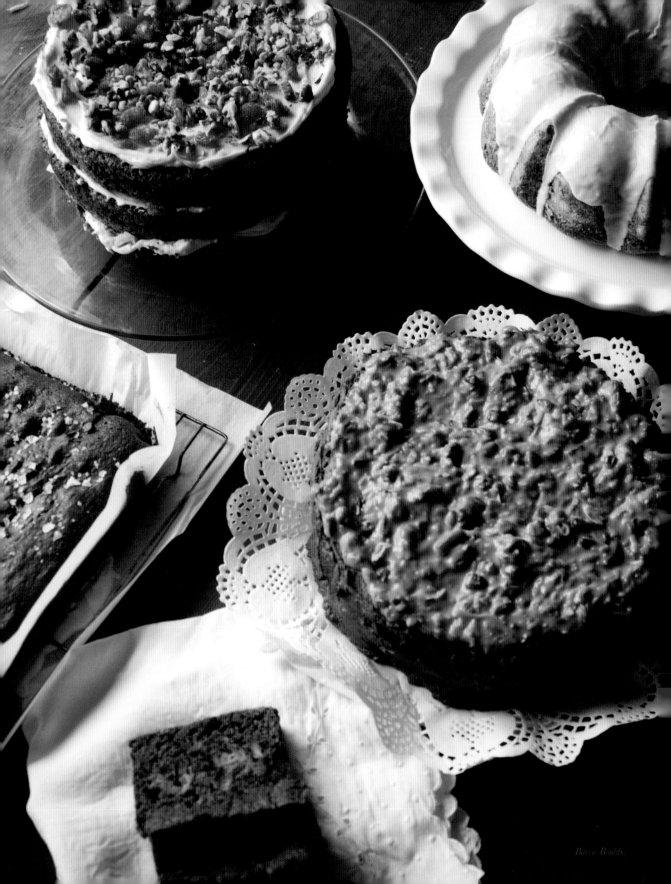

Bruce Budds.

PART V. DESSERTS

Toward the turn of the twentieth century, more land was being sold in orchard parcels, and homesteaders were arriving by rail to the fertile lands of the Bitterroot Valley, where the McIntosh apples of Montana were boasted as "the largest apple orchards in the world!" Even with a short growing season, there are many apples that thrived despite the weather odds against them, and those favorites to many growers are Carroll, Empire, Goodland, Haralson, Lodi and, last but certainly not least, McIntosh.

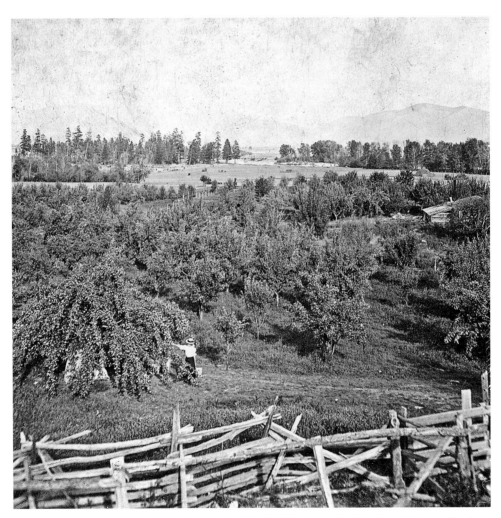

Apples ready to pick, Missoula County [no date, circa 1900–1920]. Photograph by N.A. Forsyth. *Montana Historical Society Research Center Photograph Archives, Helena, MT.*

GRANDMA'S RAW APPLE COFFEE CAKE

SERVES 6–8

"THIS WAS A MORNING TREAT AT MY GRANDMA'S HOUSE. SHE WOULD LET US HAVE A DRINK FROM HER STOVE-TOP PERCOLATOR COFFEE AND WOULD TEASE US THAT IT WOULD 'STUNT OUR GROWTH.' OUR IRISH CATHOLIC GRANDMOTHER WAS A 'SAINT,' AS MY DAD CALLED HER, AND SHE WENT TO CHURCH EVERY DAY AND TWICE ON SATURDAY."—CHEF BOULDS

1 cup white sugar
½ cup (1 stick) unsalted butter, room temperature
1 beaten egg
1 teaspoon baking soda, dissolved in ½ cup hot coffee
1 cup raw apples, peeled and chopped fine
½ teaspoon each of ground nutmeg, ground cloves and ground cinnamon
1½ cups all-purpose flour
1 cup raisins
½ cup walnuts (optional)

Preheat oven to 350 degrees. Cream together sugar and butter and then add the egg, soda in coffee, apples, nutmeg, cloves, cinnamon and flour and beat together thoroughly. Fold in the raisins and nuts. Place batter in 8x8 pan or 10x3 loaf pan. Bake for 1 hour.

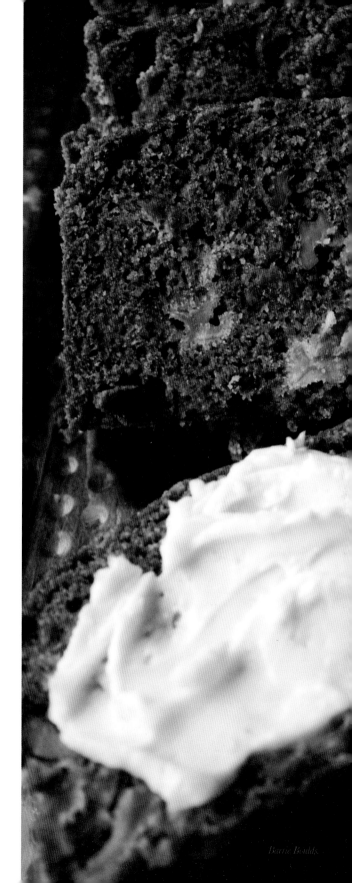

Barrie Boulds

MONTANA MONSTER "COWBOY" COOKIES

MAKES 3 DOZEN

"WE WOULD ALWAYS TAKE THIS 'MONSTER' COOKIE TO BRANDINGS. IT IS GREAT BECAUSE WE WOULD THROW WHATEVER WE HAD INTO THE BATTER—PEANUTS, BUTTERSCOTCH CHIPS AND ANY OTHER NUTS. IT'S ALSO EASY TO THROW INTO A BACKPACK FOR A HIKE."—CHEF BOULDS

1 cup Crisco shortening or 2 sticks unsalted butter

1 cup brown sugar

1 cup white sugar

1½ cups peanut butter

3 eggs

2 teaspoons baking soda

½ teaspoon kosher salt

4½ cups instant rolled oats

½ package chocolate chips

½ package M&Ms

1 teaspoon vanilla

Preheat oven to 350 degrees. Cream shortening and sugars and add peanut butter, then add 1 egg at a time and blend well with a handheld or countertop mixer. Sift dry ingredients through fine mesh sieve and add with M&Ms and vanilla to creamed ingredients. Roll into large 4-ounce balls and place onto slightly greased cookie sheets or parchment paper; do not flatten. Bake about 12 minutes, until slightly undercooked. Cool before removing from pans.

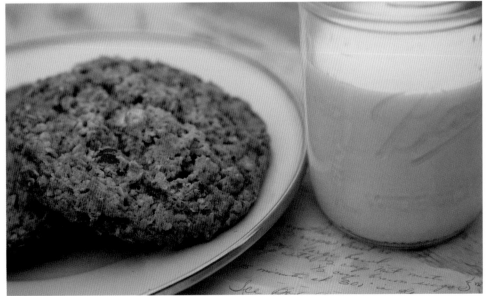

Nicole O'Shea.

CRÈME BRÛLÉE

SERVES 10

"THIS RECIPE WAS GIVEN TO ME BY A FRENCH CHEF WHO HAD DINNER AT MY BISTRO. HE TOLD ME THIS
WAS HIS SECRET RECIPE FROM HIS RESTAURANT AND ASKED ME TO PLEASE TAKE THIS WITH LOVE."
—CHEF BOULDS

5 cups heavy cream

1 cup whole milk

2 vanilla beans, split open and insides scraped to 1 teaspoon

12 organic egg yolks

1 cup white sugar

1½ teaspoons turbinado sugar for each ramekin

Fresh huckleberries, as garnish

Preheat oven to 300 degrees. Put the heavy cream, milk, vanilla beans and pulp (the inside of the vanilla bean) into a saucepan. Heat to almost a boil and remove from heat. Allow to cool slightly. Remove the vanilla beans. Whisk together the egg yolks and sugar in a bowl. Slowly add the cream mix into the yolk/sugar mixture until all incorporated, stirring constantly. When combined, pour into 10 4-ounce ramekins set in a large cake or roasting pan. Pour enough hot water to come a little less than halfway up the sides of the ramekins. Bake about 25 minutes until it is just set and barely jiggles in the middle. Remove ramekins from water bath, let cool, cover and refrigerate for 2 hours or overnight. Divide sugar among ramekins and shake evenly across top. With a torch, melt the sugar until it caramelizes. Top with fresh Montana huckleberries.

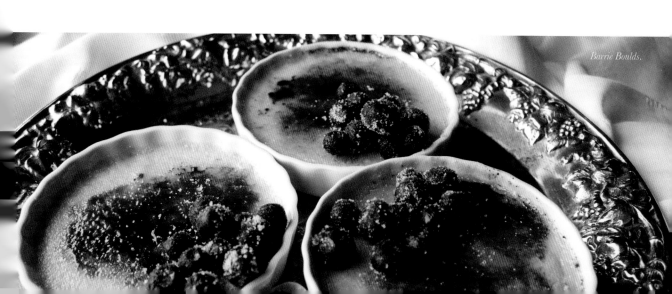

Barrie Boulds.

GRANDMA VIVIAN (O'TOOLE'S) RUM CAKE

SERVES 8-10

"This was the only time Grandma Vivian O'Toole would partake of alcohol. She would laugh for a good hour after eating this cake, even though she was already nicknamed the 'laughing Grandma.' When I bake it now, I always smile remembering my 'laughing Grandma.'"—Chef Boulds

1 box yellow cake mix

6 tablespoons all-purpose flour

1 cup rum

¾ cup vegetable oil or 1½ sticks unsalted butter, melted

4 eggs

1 small box instant vanilla pudding

1 teaspoon ground nutmeg

DRY MIXTURE

2 tablespoons brown sugar

2 tablespoons white sugar

1 teaspoon ground cinnamon

¾ cup chopped nuts, preferably pecans

FROSTING

1½ cups confectioner's sugar

2 tablespoons (¼ stick) unsalted butter, melted

Rum, any kind, as needed for consistency

Preheat oven to 350 degrees. Mix all cake ingredients with a handheld mixer and set aside. Oil and flour a bundt cake pan. Spoon half the cake mix dough evenly into the bundt pan. Sprinkle dry mixture over the cake dough. Spoon the rest of the cake dough mixture on top to cover.

Bake for 50 minutes. When cake has cooled in pan, take a knife and go around outer edges of pan and center. Tip upside down on a large cake plate. With a toothpick, poke holes in top of cake. Mix the first two ingredients of frosting and enough rum to make a medium-thin frosting. Pour over cake, letting it run down the sides.

Barrie Boulds.

Jean Petersen.

RHUBARB CRUNCH

SERVES 12-14

"Rhubarb is a very tart, fibrous plant that is usually not eaten on its own. The leaves are poisonous and should be removed before using in cooking. We had a huge rhubarb patch in the middle of our garden that my dad transplanted from my grandma's garden. We ate a lot of rhubarb pies and jams growing up."—Chef Boulds

2 cups all-purpose flour

1 ½ cups uncooked oatmeal

2 cups brown sugar

1 cup (2 sticks) unsalted butter, melted

2 teaspoons cinnamon

8 cups fresh rhubarb, chopped

2 cups white sugar

4 tablespoons cornstarch

2 cups water

2 teaspoons vanilla extract

Preheat oven to 350 degrees. Mix flour, oatmeal, brown sugar, butter and cinnamon into a crumble and put half of it in a 9x13 pan. Press firmly on the bottom. Save remaining as a topping. Place rhubarb over crumb mixture. Cook last four ingredients together over medium heat until mixture is thick and clear, stirring constantly. Pour over rhubarb. Top with rest of crumble. Bake for 1 hour. Cut in squares and serve warm or cold with fresh whipped cream.

CHEF'S NOTE: Do not use frozen rhubarb for this dish, as it makes it very watery and then it soaks into the topping and thus the top won't crisp properly.

Jean Petersen

CHOCOLATE LAVA CAKE
with BRANDIED MONTANA FLATHEAD CHERRIES

SERVES 4

"THIS CAKE IS SUPER EASY TO MAKE AND 'WOWS' MY GUESTS EVERY TIME. I LIKE TO ADD MONTANA FLATHEAD CHERRIES IN A BRANDY SAUCE WHEN THE CHERRIES ARE IN SEASON."—CHEF BOULDS

½ cup (1 stick) unsalted butter

6 ounces bittersweet chocolate, such as Ghirardelli's

1 teaspoon instant espresso

Pinch of salt

2 eggs

2 egg yolks

¼ cup white sugar

2 tablespoons all-purpose flour

4 teaspoons unsweetened European chocolate

BRANDIED MONTANA FLATHEAD CHERRIES

1 to 2 pounds Flathead cherries, pitted

1 cinnamon stick

1 cup white sugar

2 cups brandy, any kind

¾ cup orange juice

1 teaspoon vanilla extract

Preheat oven to 450 degrees. Melt butter and bittersweet chocolate in the microwave in 30-second increments, stirring each time until completely melted, and then stir in the instant espresso and salt. Beat together the eggs, yolks and sugar with a handheld mixer until thickened. Slowly, pour the egg mixture into the chocolate while beating, and then fold in the flour with a wooden spoon by hand. Spray four ramekins with nonstick spray and dust with unsweetened European chocolate. Divide mixture among the ramekins equally and place on a baking sheet. Bake for 8 to 10 minutes, until sides are set. Invert each ramekin on the serving plate and let it sit for 30 seconds, then lift the ramekin away from the cake. Spoon Brandied Flathead Cherries over the top.

FOR THE CHERRIES: Combine all of the ingredients in a medium saucepan and bring to a boil. Let it boil for 2 minutes and reduce heat. Allow the mixture to reduce until slightly thickened, about 10 to 12 minutes. Remove from the heat and cool. This can be made a day ahead and refrigerated. Bring to room temperature and pour over hot Chocolate Lava Cakes. The mixture will keep in the refrigerator for up to 2 weeks.

Nicole O'Shea.

NON-GERMAN CHOCOLATE CAKE

SERVES 8-10

"I love to call this my 'Non-German Chocolate Cake' when I make this for clients and friends and tell them the real story of why it's not really a 'German' Chocolate Cake. Everyone enjoys the story, and many have never heard it before."—Chef Boulds

German Chocolate Cake is actually not German, as many believe, and definitely not from Germany. It was named for the chocolate baker Sam German, an English-American who developed this sweet dark chocolate formulation in 1852 for the Baker's Chocolate Company. The chocolate company named it after the chocolate maker in his honor: Baker's German's Sweet Chocolate. In 1957, a homemaker in Texas submitted her "Recipe of the Day" to the *Dallas Morning News* using this dark chocolate creation developed over one hundred years prior and called her recipe German's Chocolate Cake. Since then, it has become a vastly popular recipe. The possessive "s" was dropped through subsequent publications, and it is now called German Chocolate Cake.

CAKE

¾ cup (1½ sticks) unsalted butter

1¼ cups dark unsweetened
 cocoa powder

1 cup brewed espresso

2 cups buttermilk

1½ cups brown sugar

1½ cups white sugar

3 eggs, lightly beaten

1 tablespoon vanilla extract

2¼ cups flour

1 teaspoon baking soda

¾ teaspoon salt

NON-GERMAN CHOCOLATE
FROSTING

1½ cups toasted pecan pieces

1 cup brown sugar

2 cans evaporated milk

3 egg yolks

½ cup (1 stick) unsalted butter

3 teaspoons vanilla extract

3 cups toasted sweetened flaked coconut

MILK CHOCOLATE FROSTING

2 cups milk chocolate chips

1 cup (2 sticks) unsalted butter, softened

5 teaspoons dark unsweetened cocoa
 powder

1 teaspoon vanilla

5 cups confectioner's sugar

3 to 6 tablespoons buttermilk

Preheat oven to 350 degrees. At the bottom of three 8-inch pans, place a greased parchment paper that is cut into a circle the size of the pan and spray with nonstick spray. Spray again on the top of the paper. Melt butter in the microwave and add cocoa powder. Stir. Add the espresso and buttermilk slowly to combine. Add sugars, eggs and vanilla and whisk until smooth. Combine the flour, baking soda and salt. Add to the butter/chocolate mixture until combined. Divide evenly among the three prepared pans. Bake for 35 to 45 minutes, or until toothpick comes out mostly clean.

Cool before removing cakes from pans. Use a sharp knife to loosen edges if needed. Cool completely before frosting. Can wrap in plastic wrap and refrigerate until ready to frost.

Fill middle layers and the top of the cake with Non-German Chocolate Frosting. Frost the edges with the Milk Chocolate Frosting.

FOR THE NON-GERMAN CHOCOLATE FROSTING: *Lightly toast pecans in oven or in a pan on the stove. Combine sugar, evaporated milk, yolks and butter. Cook on stove, whisking constantly, until bubbling and thickened, about 10 to 15 minutes, being careful not to burn. Add vanilla, coconut and pecans. Cool and refrigerate before frosting cake.*

FOR THE MILK CHOCOLATE FROSTING: *Melt chocolate in microwave in 30-second increments, stirring often to not burn. Beat melted chocolate and room-temperature butter together with a handheld mixer. Add cocoa powder and vanilla and then alternate confectioner's sugar and buttermilk until desired consistency to a spreadable frosting.*

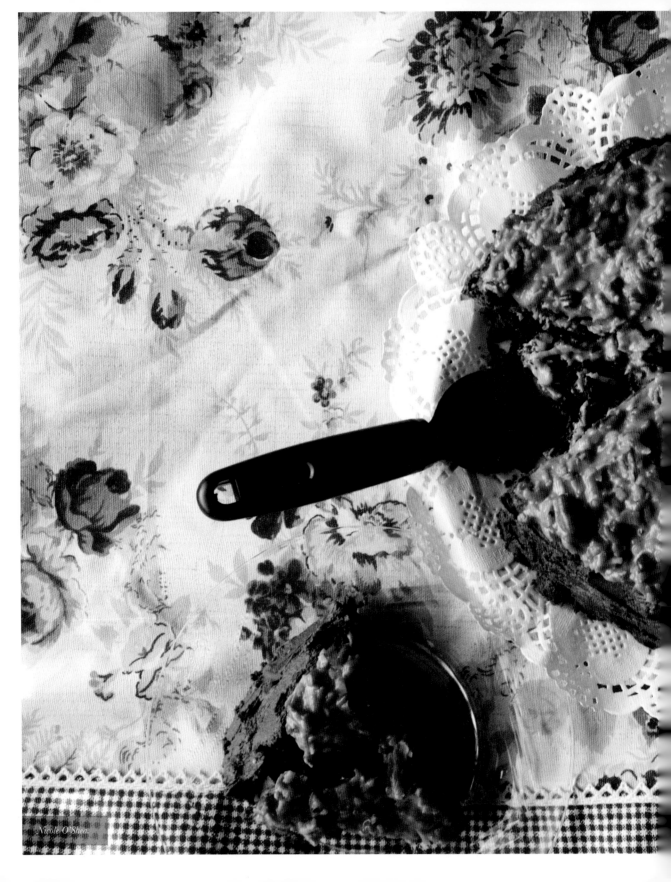

Nicole O'Shea.

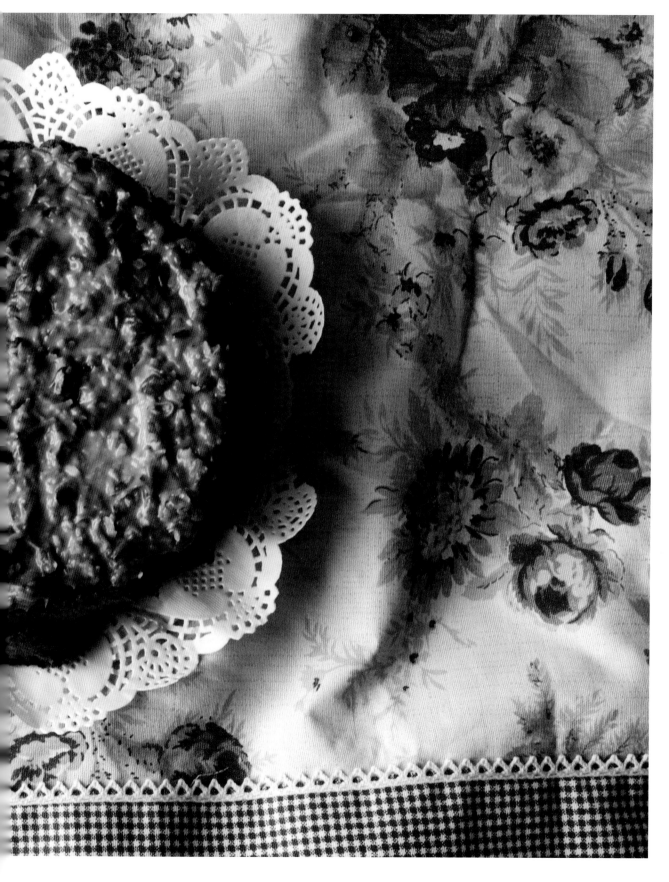

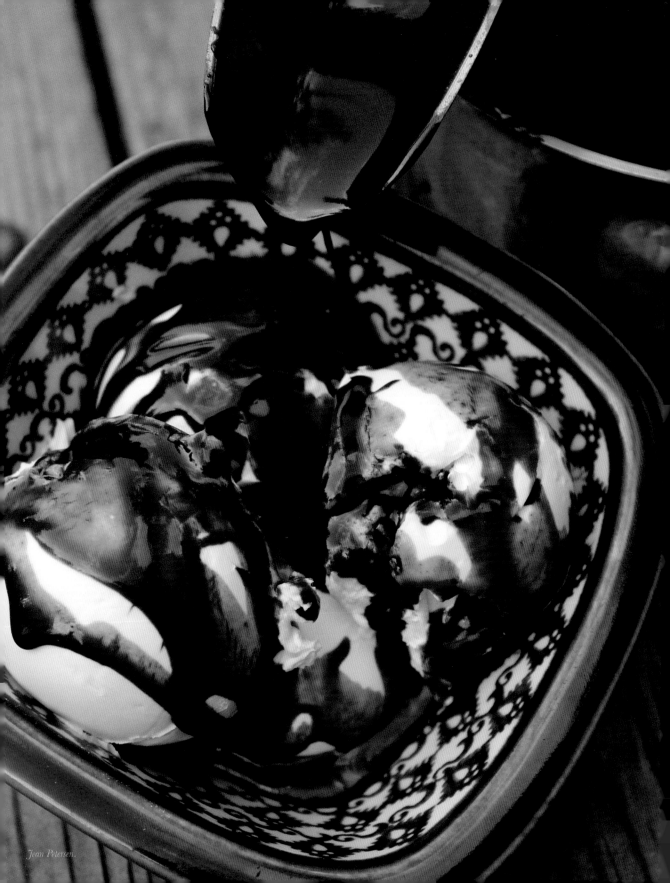

Jean Petersen.

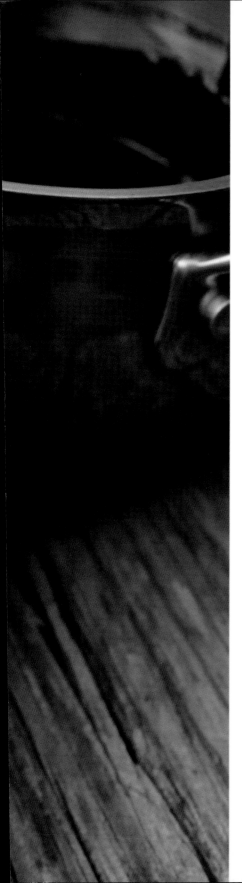

BARRIE'S FAMOUS FUDGE SAUCE

MAKES 3 CUPS

"I COULD NEVER FIND A FUDGE SAUCE I LIKED, SO I COMBINED SEVERAL FUDGE SAUCE RECIPES AND ADDED MY OWN TOUCH TO IT. THIS SAUCE IS GREAT ON SUNDAES OR OVER PLAIN VANILLA ICE CREAM."—CHEF BOULDS

1 pound bittersweet chocolate, chopped
3 ounces unsweetened chocolate, chopped
¾ cup (1¼ sticks) unsalted butter
1 14-ounce can sweetened condensed milk
1 cup light corn syrup
¼ teaspoon salt
1 tablespoon vanilla extract
1 tablespoon unsweetened cocoa powder
¾ cup hot coffee

Combine all ingredients except for the coffee and melt in a double boiler.* It's very important to not overheat! Remove from heat and whisk in coffee.

*In lieu of a double boiler, a small metal or glass bowl can be placed over a small saucepot containing simmering water. Make sure the bowl is slightly larger than the pot's circumference so that it rests on the rim of the pot, not touching the simmering water. You are looking for a gentle steam while whisking.

LEMON TART *with* FRESH FRUIT

SERVES 12

"I really don't like sweet desserts for dessert, but I do love lemon, and this tart satisfies my lemon cravings. The dessert also looks so elegant. I make this a lot for fundraisers and charity auctions."—Chef Boulds

DOUGH

1½ cups all-purpose flour

3 tablespoons white sugar

¼ teaspoon salt

¾ cup (1¼ sticks) cold unsalted butter, diced

5 to 7 tablespoons ice water

FILLING

1½ cups white sugar

3 eggs

1 tablespoon lemon zest

½ cup fresh lemon juice

¼ cup all-purpose flour

1 tablespoon confectioner's sugar (optional)

Fresh fruit (huckleberries, strawberries, kiwi, blueberries, blackberries, raspberries)

Preheat oven to 400 degrees. Mix flour, sugar and salt in a bowl. Cut in cold butter by hand and add enough water until dough barely comes together and forms a ball. Dough should be refrigerated up to 1 hour, until cold enough to handle and roll out. Roll dough into a 12-inch circle, place in a tart pan and refrigerate for 20 minutes. In the meantime, prepare tart filling ingredients.

Whisk sugar and eggs. Zest lemon and then squeeze fresh lemon juice and combine with sugar and eggs. Add flour and continue to whisk slowly until combined. Pour mixture into pan over the dough. Bake for 35 to 40 minutes (aluminum foil around the dough crust will prevent it from burning). Once cooked, remove, let cool and dust with confectioner's sugar (optional) and garnish with fresh fruit.

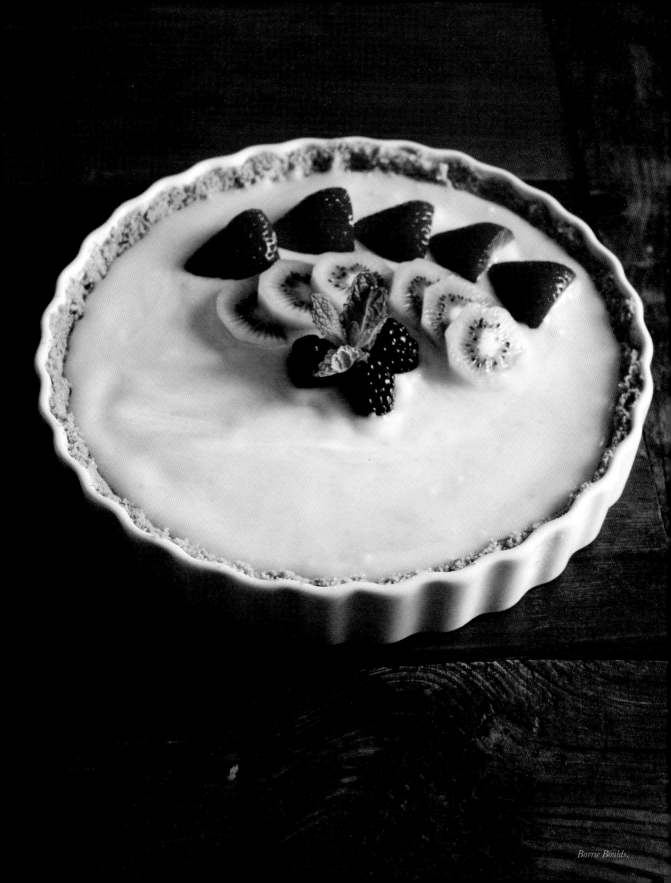

Barrie Boulds.

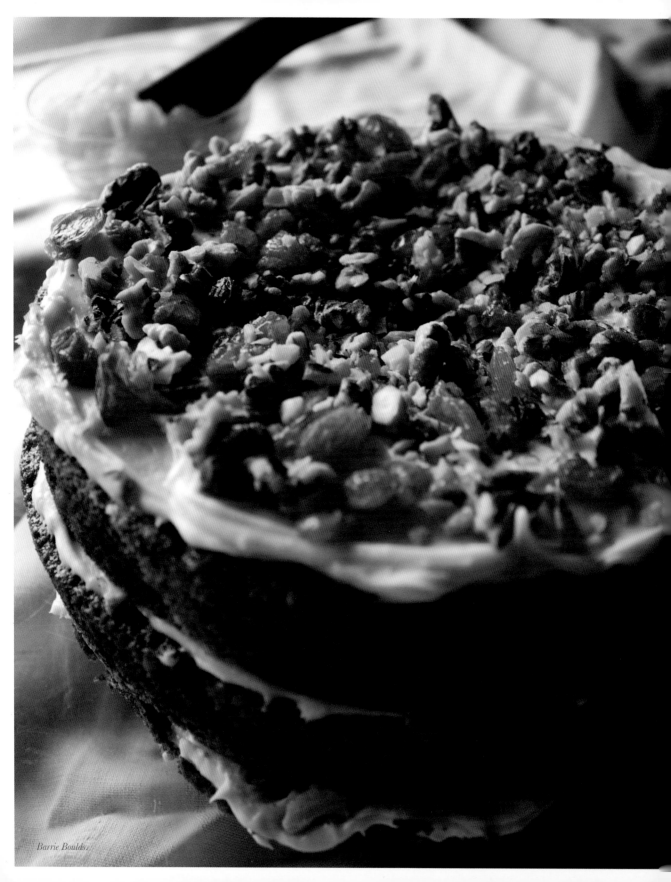

Barrie Boulds

CARROT CAKE

SERVES 8–10

"I love to buy local, fresh organic carrots from farms or farmers' markets. You would not believe the taste difference between a local, organic carrot compared to a store-bought carrot. This carrot cake is oh so yummy with fresh carrots!"—Chef Boulds

2 cups white sugar

¾ cup applesauce

¾ cup vegetable oil

4 large eggs

2 cups all-purpose flour

2 teaspoons baking powder

2 teaspoons baking soda

1 teaspoon salt

1 teaspoon ground cinnamon

¾ teaspoon ground nutmeg

3 cups carrots, peeled and finely grated

1½ cups pecans, chopped and toasted

1½ cups golden raisins

FROSTING

4 cups confectioner's sugar

2 8-ounce packages cream cheese, room temperature

½ cup (1 stick) unsalted butter, room temperature

1½ teaspoons vanilla extract

Preheat oven to 325 degrees. Lightly grease three 9-inch cake pans with 1½-inch-high sides. Line bottom of pans with parchment paper cut into circles of the pan size and lightly grease paper. Using electric mixer on medium speed, beat sugar, applesauce and vegetable oil in bowl until combined and then add eggs one at a time, beating well after each addition. Sift flour, baking powder, baking soda, salt, cinnamon and nutmeg into sugar and oil mixture. Stir in carrots, ½ cup of the chopped pecans and ½ cup raisins. Pour batter into prepared pans, dividing equally. Bake until toothpick inserted into center comes out clean and cakes begin to pull away from sides of pans, about 45 minutes. Cool in pans on racks for 15 minutes. Turn out cakes onto racks and cool completely. The cakes can be made the day before. Wrap tightly in plastic and store in the refrigerator.

Place one cake layer on a cake platter. Spread with ¾ cup frosting, ¼ cup pecans and ¼ cup raisins. Repeat this process with the next layer. Top with remaining cake layer. Using icing spatula, spread remaining frosting in decorative swirls over sides and top of cake. Put the remaining pecans and raisins on the top of the cake. Cover with cake dome and refrigerate. Serve cake cold or at room temperature.

FOR THE FROSTING: *Using electric mixer, beat all ingredients in medium bowl until smooth and creamy and to a spreadable consistency.*

AUNT LOIS O'TOOLE'S RHUBARB STRAWBERRY PIE

SERVES 6-8

"Aunt Lois O'Toole is actually my dad's first cousin Jim O'Toole's wife, but we grew up calling them aunt and uncle. When we would visit our grandma in Plentywood for the day on Sundays, we would usually stop along the way in all the smaller little towns on the way home—Reserve, Antelope, Medicine Lake and Froid. Aunt Lois and Uncle Jim owned the Mint Bar and Café in Froid, Montana, and we'd stop and get pie there for dessert after our dinner of fried chicken in Reserve. Lois' original pie recipe calls for rhubarb only, but I like strawberry too so did half and half."—Chef Boulds

3 beaten eggs
1¼ cups white sugar, plus a little to sprinkle
 on top
2 tablespoons all-purpose flour
2 tablespoons orange juice
1 grated orange zest
2 cups fresh rhubarb, chopped
2 cups fresh strawberries, quartered
Perfect Pie Crust (see page 161)

Preheat oven to 450 degrees. Beat eggs and add sugar, flour, orange juice and zest. Pour over rhubarb and strawberry in a prepared pie crust in a pie pan. Top with the other pie crust, brush with a little water and sprinkle sugar on top. Bake at 450 degrees for 15 minutes. Then turn down heat to 350 degrees and bake for 30 minutes until lightly browned on top.

CHEF'S NOTE: It is very important to use fresh rhubarb and strawberries for this pie recipe. It will become watery if you use frozen. This is a great example of a seasonal dish!

Nicole O'Shea.

SEA SALT BROWNIES

MAKES 1 DOZEN BROWNIES

"I COULD NEVER SEEM TO FIND THE PERFECT BROWNIE—CRUSTY ON TOP AND ALMOST CAKE LIKE IN THE MIDDLE. I HAVE BEEN EXPERIMENTING WITH DIFFERENT RECIPES FOR YEARS, AND I THINK THIS RECIPE IS NEAR PERFECT FOR WHAT I WANTED."—CHEF BOULDS

1½ cups (3 sticks) unsalted butter

3 cups white sugar

2½ cups plus 2 tablespoons unsweetened cocoa powder (natural or Dutch process)

¾ teaspoon salt

1½ teaspoons vanilla extract

6 large cold eggs

1½ cups all-purpose flour

⅔ cup walnut or pecan pieces (optional)

Flaked sea salt

Barrie Boulds.

Preheat oven to 375 degrees. Line the bottom and sides of a 9x13 baking pan with parchment paper or aluminum foil, leaving an overhang on two opposite sides. Combine the butter, sugar, cocoa and salt in a medium heatproof bowl and set the bowl on a large saucepan of simmering water. Stir occasionally until butter is melted and smooth. It should be hot enough that you want to remove the tip of your finger quickly when testing it. Remove the bowl from the pan and set aside until the mixture is warm and not hot. Stir in vanilla with a wooden spoon. Add the eggs one at a time; stir quickly after each egg. When the batter looks thick, shiny and well blended, add the flour and stir just until you cannot see it any longer, then beat rapidly for about 30 more strokes with a wooden spoon. Stir in the nuts. Spread evenly in the lined pan. Put pan on the lowest rack in the oven and turn oven down to 325 degrees. Bake for 20 to 25 minutes or until a toothpick is slightly moist when dipped in the center for testing. Top with flaked sea salt while still warm. Cool completely on a rack. Once cool, lift the ends of the parchment or aluminum foil, transfer the brownies to a cutting board and cut into squares.

AUTHENTIC NEW YORK CHEESECAKE

SERVES 8-10

"This New York Cheesecake is very big, unlike other cheesecakes. I usually do everything in my food processor, and the texture comes out incredible. This is the 'mack daddy' of all cheesecakes, in my book. I love to put macerated strawberries or strawberries soaked in red wine on top!"—Chef Boulds

CRUST

1½ cups graham cracker crumbs

2½ tablespoons unsalted butter, room temperature

1½ tablespoons white sugar

CHEESECAKE

2½ pounds cream cheese

1 lemon, zest and ½ teaspoon juice

1 orange, zest and ½ teaspoon juice

½ teaspoon vanilla extract

1½ cups white sugar

3 tablespoons all-purpose flour

5 eggs

2 egg yolks

½ cup sour cream

Preheat oven to 375 degrees. Butter the bottom of a 9-inch springform pan with 3-inch sides. In a bowl, combine graham crackers, butter and sugar and mix well. Press in the bottom of the pan and bake until light gold in color, about 8 minutes. Remove and let cool. Lower oven temperature to 350 degrees.

When pan is cool, butter remaining sides and wrap pan bottom and sides in several layers of aluminum foil. With a mixer, mix cream cheese, lemon and orange zest, lemon and orange juice, vanilla extract and sugar until smooth and light. Continue blending while gradually adding flour and each egg and yolk individually until completely mixed in batter. Add the sour cream last and beat until smooth. Pour into cheesecake pan and set it in a roasting pan with enough hot water to come halfway up the side of the pan. Bake for 1 hour and 20 minutes, making sure to check that top isn't browning too quickly; you can cover with an aluminum foil tent if it is. Remove when center does not jiggle. Cool completely on a wire rack, refrigerate overnight in pan and keep in refrigerator until serving.

OPTIONAL: Macerated strawberries: Combine 1 pint (2 cups) strawberries, washed, hulled and sliced, with 2 tablespoons sugar; let sit out at room temperature for 30 minutes to 1 hour. Use as topping for desserts. Wine-soaked strawberries: Same as macerated strawberries, but add ½ cup of dry red wine and refrigerate for 2 to 3 hours before serving.

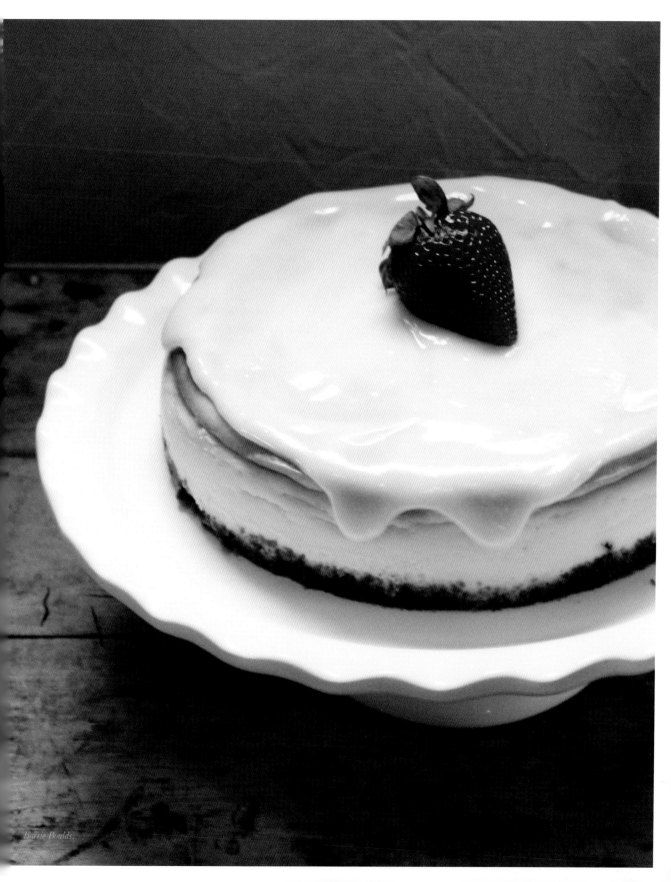

Barrie Boulds.

APPLE PIE

SERVES 6–8

"NOTHING SAYS AMERICA LIKE
APPLE PIE. THIS IS A GREAT PIE TO
BRING TO A FAMILY GET-TOGETHER
AND IS DELICIOUS WITH A SIDE OF
VANILLA ICE CREAM."
—CHEF BOULDS

6 to 8 tart apples, like Granny
 Smith, peeled and sliced
½ cup (1 stick) unsalted butter
3 tablespoons all-purpose flour
¼ cup water
½ cup white sugar
½ cup brown sugar
Perfect Pie Crust (see page 161)
1 egg mixed with 1 teaspoon
 of water
1 tablespoon turbinado sugar

*Preheat oven to 425 degrees. Peel
apples and combine with next five
ingredients. Put into prepared pie
crust. Cover or lattice remaining
pie crust over the top of the pie.
Brush top with egg wash and
sprinkle with turbinado sugar.
Cook for 20 minutes, turn heat
down to 350 degrees and cook
another 25 to 30 minutes, until
lightly browned.*

Nicole O'Shea

BIG SKY BLUEBERRY PIE

SERVES 6–8

"I'M NOT MUCH OF A PIE EATER, BUT I ALWAYS GET ASKED TO MAKE PIE FOR PICNICS OR BARBECUES. THIS IS MY GO-TO PIE RECIPE, AS IT IS THE EASIEST TO MAKE OUT OF ALL MY PIES."—CHEF BOULDS

4 pints (8 cups) fresh blueberries
1 lemon, zested
1 tablespoon lemon juice
¼ cup all-purpose flour
½ cup white sugar
¾ tablespoon ground cinnamon
Perfect Pie Crust (see page 161)
2 tablespoons (¼ stick) unsalted butter
1 egg mixed with 1 teaspoon of water
1 tablespoon turbinado sugar, for top

Preheat oven to 425 degrees. Combine fresh blueberries, lemon zest and juice, flour, sugar and cinnamon together in a bowl. Pour ingredients into pie pan lined with prepared pie crust. Place pats of butter on top of the pie filling. Cover or lattice remaining pie crust over top of pie. Brush top with egg wash and sprinkle with turbinado sugar. Cook for 20 minutes, turn heat down to 350 degrees and cook another 25 to 30 minutes, until lightly browned.

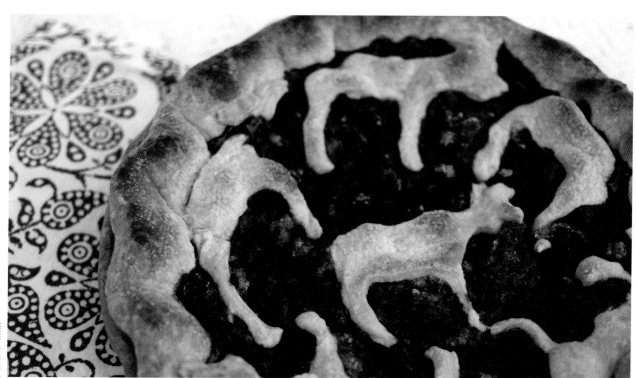

SIMPLE BLUEBERRY DESSERT

SERVES 2–4

"This was my dad's favorite treat. My dad would make this for me as a kid, and I just remember how he would get all excited about how much he loved this dessert; it made my heart happy. It's beyond simple, and it brings back such wonderful memories of a simpler time."—Chef Boulds

1 cup fresh blueberries
½ tablespoon white sugar
⅓ cup fresh half-and-half
Fresh mint

Place rinsed blueberries in a bowl, sprinkle with sugar and pour half-and-half over the top. Garnish with fresh mint.

Nicole O'Shea.

PERFECT PIE CRUST

MAKES 2 9-INCH PIE CRUSTS

"THIS VERSION PAYS HOMAGE TO MRS. H. TIMMERMAN, THE MOTHER OF MY FATHER'S BEST FRIEND
SHORTY TIMMERMAN, AND HER RECIPE FROM THE WOMEN'S MISSIONARY FEDERATION COOKBOOK OF
PLENTYWOOD, MONTANA, PRINTED IN 1937."—CHEF BOULDS

½ cup (1 stick) unsalted butter, frozen
1½ cups all-purpose flour
¼ teaspoon salt
¼ teaspoon baking powder
Ice water

In a food processor or by hand, add the frozen butter, cut into chunks, to the dry mixture and pulse until you have pea- to dime-size pieces throughout. Slowly add very, very cold ice water to form a ball of dough. Start with ¾ cups of water, added slowly, until your pie dough forms into a ball. You might not need all the water. Separate the dough into two round discs, wrap in plastic wrap, and refrigerate ½ hour before rolling out and using.

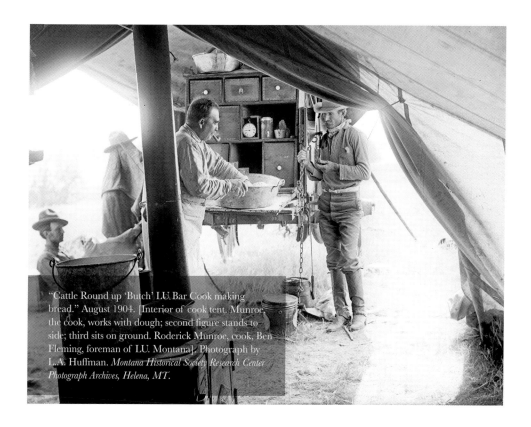

"Cattle Round up 'Butch' LU Bar Cook making bread." August 1904. [Interior of cook tent. Munroe, the cook, works with dough; second figure stands to side; third sits on ground. Roderick Munroe, cook, Ben Fleming, foreman of LU, Montana]. Photograph by L.A. Huffman. *Montana Historical Society Research Center Photograph Archives, Helena, MT.*

PART VI. BREADS

MONTANA BREAD STICKS

SERVES 8-10

"This recipe is my daughter Sydney's Grandma Lorna Vannatta's recipe. She includes it in all the local community cookbooks and brings it to many gatherings. The bread sticks are delicious, and I can see why she's asked to make them all the time."—Chef Boulds

¾ cup extra virgin olive oil
¾ cup water
¾ cup light beer
1 package active dry yeast
1 teaspoon salt
4½ cups all-purpose flour
1 egg
1 teaspoon garlic or onion salt
Dried rosemary (optional)

Preheat oven to 350 degrees. Mix together oil, water and beer in a saucepan. Heat until lukewarm. Add yeast and stir, then add salt and flour. Let rise. Once lifted, punch down and make into bread sticks (roll thin). Beat egg in a small bowl, and before baking, brush each bread stick with the whole beaten egg and sprinkle with onion or garlic salt and dried rosemary. Bake in oven for 30 to 45 minutes on ungreased cookie sheets. Store uncovered.

Nicole O'Shea.

Barrie Boulds.

100 PERCENT EASY WHOLE WHEAT ROLLS

SERVES 12

"This absolute no-fail roll or bread recipe comes from Lorna Vannatta's family in Froid, Montana. She used these rolls all the time, and they've always been a personal favorite of mine."—Chef Boulds

1 quart (4 cups) warm water
 (about 112 degrees)
2 packages active dry yeast
1 tablespoon salt
¼ cup canola oil
⅔ cup honey, preferably local
8 cups whole wheat flour

Preheat oven to 450 degrees. Place water in a large mixing bowl. Stir in yeast, salt, oil and honey until well blended. Add flour gradually, beating well, until the dough is slightly more moist than regular bread dough. Let the dough rest for 10 minutes. Turn out onto a floured board and knead dough until smooth (about 10 minutes). Place in a clean greased bowl. Cover and let rise in a warm place until double in bulk (about 1½ to 2 hours). Punch dough down and shape into 1- to 2-ounce rolls or two large loaves. Place on sheet pans an inch apart, cover and let rise until it doubles in bulk, about 45 minutes. Put rolls or loaves in oven and reduce heat to 350 degrees. Bake for 20 to 25 minutes for rolls or 45 to 60 minutes for loaves.

At the turn of the twentieth century, farms had expanded fourfold, and wheat farming was exceptionally popular; it continues to be Montana's leading cash crop. With nearly nine thousand wheat farms, the most productive portion of the state is in the north central region, referred to as "Montana's Golden Triangle," with the points being Havre, Conrad and Great Falls. Montana ranks third in the United States for wheat production and yields over 185 million bushels per year, as sourced in the most recent Ag Statistics.

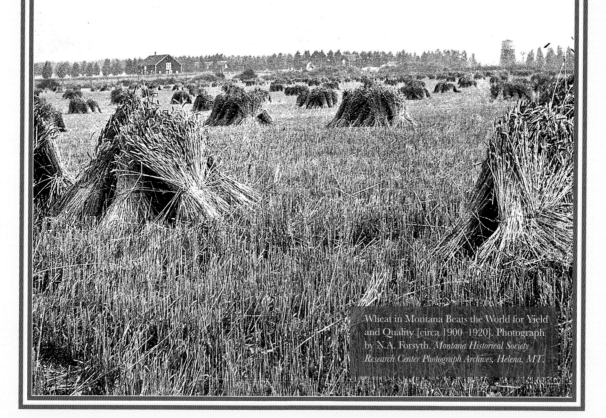

Wheat in Montana Beats the World for Yield and Quality [circa 1900–1920]. Photograph by N.A. Forsyth. *Montana Historical Society Research Center Photograph Archives, Helena, MT.*

NORWEGIAN ROLLS

MAKES 1½ DOZEN ROLLS

"My mother is of Norwegian heritage, so I really wanted to have a recipe passed down from her family. This isn't quite passed down, as I don't think her mom was a baker and neither was my mother. My mom is always teasing me and telling me that I sure didn't get my cooking ability from her. This recipe includes my added touches."—Chef Boulds

4 cups hot whole milk

2 tablespoons salt

2 cups white sugar

1 cup (2 sticks) unsalted butter

2 packages active dry yeast soaked in
 1 cup warm water

17 to 18 cups all-purpose flour
 (approximately)

3 eggs

INTERIOR SPREAD

1 cup (2 sticks) unsalted butter

1 cup brown sugar

1 cup white sugar

½ cup cinnamon

FROSTING

2 cups confectioner's sugar

½ cup cold whole milk (approximately)

Heat milk, salt and sugar in saucepan for about 5 minutes. Add butter and let cool. Soak yeast in water and add 6 cups flour to the cooled milk mixture before adding yeast. Add the yeast and 6 cups more flour. Beat well. Add eggs, 1 at a time, then the rest of the flour. Knead well, about 10 minutes. Let the dough rise for 1½ to 2 hours. Punch down dough and let it rise until it doubles again, another 1½ to 2 hours. Split the dough in half. Roll into 18x12 rectangles. Heat oven to 350 degrees. In another saucepan, melt 1 cup butter and mix 1 cup brown sugar, 1 cup white sugar and ½ cup cinnamon. Cool slightly and spread on the dough. Roll long side up and cut into 2-inch rolls. Place rolls next to each other in pan and let rise again 30 minutes to 1 hour. Place in oven and bake for 30 minutes. For frosting, mix confectioner's sugar and milk together slowly into a smooth, light topping; not all the milk may need to be used, per your desired thickness of the frosting. Remove rolls from oven and drizzle with frosting.

Jean Petersen.

BANANA BREAD

MAKES 1 LOAF

"I always like to make banana bread and bring it to my neighbors or friends just as a kind gesture. I usually put my ripe bananas in the freezer, and right before baking, I take them out. They come right out of the banana skin, and the texture is perfect for the bread."
—Chef Boulds

1 cup white sugar
½ cup (1 stick) unsalted butter
1 teaspoon lemon juice
1 teaspoon vanilla extract
½ cup sour cream
2 eggs
1¾ cups all-purpose flour
1 teaspoon baking soda
1 teaspoon baking powder
½ teaspoon salt
3 to 4 very ripe bananas
½ cup walnuts (optional)

Preheat oven to 350 degrees. Cream sugar and butter. Add lemon juice and vanilla extract once sugar and butter is thoroughly creamed. Mix in sour cream and eggs. In a separate bowl, combine flour, baking soda, baking powder and salt. Mix together. Slowly combine dry ingredients and wet ingredients and then fold in bananas and walnuts. Pour mixture into a lightly floured or greased standard loaf pan. Bake for 45 to 60 minutes, until golden brown or a toothpick comes out clean. Cool and slice to serve.

Jean Petersen.

HOMEMADE MUFFINS *with* PECAN STREUSEL

MAKES 3 DOZEN

"IF I EVER HAVE TO MAKE MUFFINS, THESE ARE THE ONES I LIKE TO MAKE. THEY ARE A CROSS BETWEEN A MUFFIN AND A PECAN STREUSEL PASTRY."—CHEF BOULDS

Barrie Boulds.

3 eggs

2 cups white sugar

1 cup vegetable oil

1 teaspoon vanilla extract

3 cups applesauce

4 cups all-purpose flour

1 teaspoon salt

1 teaspoon baking soda

¼ teaspoon baking powder

PECAN STREUSEL

1½ cups shelled pecans, chopped fine

1 cup packed light brown sugar

¼ cup all-purpose flour

¼ cup (½ stick) unsalted butter, melted

½ teaspoon ground cinnamon

¼ teaspoon ground nutmeg

Preheat oven to 325 degrees. Line or grease muffin cups. Combine eggs, sugar, oil, vanilla and applesauce together in a bowl until smooth. Add flour, salt, baking soda and baking powder into wet mixture until smooth. Pour batter into muffin cups, about three-quarters full. Bake for 25 to 35 minutes until golden brown. While muffins are cooling, prepare Pecan Streusel.

FOR THE PECAN STREUSEL: Add chopped pecans to brown sugar, flour and melted butter and mix together. Add cinnamon and nutmeg and combine with pecan mixture. Put streusel topping on top of muffins.

IRISH SODA BREAD

MAKES 1 LOAF

"This bread is simple to make and is my favorite bread for chicken salad or turkey sandwiches."—Chef Boulds

⅓ cup white sugar

3 cups all-purpose flour

1 tablespoon baking powder

1 teaspoon baking soda

1 teaspoon salt

1 egg, beat with 2 cups buttermilk

¼ cup (½ stick) unsalted butter, melted

1 cup dried cherries or cranberries

Preheat oven to 350 degrees. Grease loaf pan. Combine sugar, flour, baking powder, baking soda and salt together in a bowl. Beat 1 egg together with buttermilk in a separate bowl. Once mixed together, add to the sugar-flour mixture. Once smooth, add butter, stir and add dried cherries or cranberries. Pour mixture into a lightly floured and greased standard loaf pan. Bake for 35 to 45 minutes until golden brown. Cool and slice to serve.

I'VE STOOD OUTSIDE MY HOUSE IN
MONTANA LOOKING AT THE NORTHERN LIGHTS...
CRACKLING AGAINST THE NIGHT SKY.
TO ME THAT'S MAGIC.

—*Christopher Paolini*

THE BASICS, EASY SUBSTITUTES AND MEASUREMENT CONVERSIONS

BASIC CHICKEN STOCK

2 roasting chickens or enough pieces to
 equal 7 pounds
2 large yellow onions, cut in half diagonally
 with skin left on
3 large carrots, washed and unpeeled,
 cut into thirds
2 large celery ribs with leaves, washed and
 cut into thirds
½ head of garlic, cut diagonally with
 skin left on
6 quarts (24 cups) warm water
1 bunch fresh parsley (or half parsley/half
 cilantro)
1 bunch fresh thyme
3 sprigs fresh rosemary
1 tablespoon coarse kosher salt
1 tablespoon whole peppercorns

Combine all ingredients in large stockpot. Bring to a boil and turn down to a gentle boil for 30 minutes. Turn down to a simmer for 1 hour, skimming off impurities that rise to the top as needed. At this point, you can remove the chicken, debone and save meat for other uses. After deboning, place bones back into stockpot and continue simmering for another 4 to 5 hours. Strain all the contents, discard and cool stock. Place in fridge overnight, and the next day, remove solidified surface fat. Use immediately or portion into Ziploc bags, filling three-quarters full, and freeze flat. Can be kept in freezer up to 3 months.

For darker broth, use dark meat, carcass and/or bones. Roast bones and vegetables, tossed in 2 tablespoons olive oil, on roasting pan in a 450-degree oven for about 45 minutes to 1 hour, until a nice golden brown. Combine with water, herbs and spices. Follow Basic Chicken Stock recipe.

BASIC BEEF STOCK

6 pounds meaty beef bones (short ribs, marrow bones, shanks, etc.)

4 tablespoons tomato paste

6 quarts (24 cups) warm water

2 large onions, cut in half diagonally with skin left on

3 large carrots, washed and unpeeled, cut into thirds

2 large celery ribs with leaves, washed and cut into thirds

½ head of garlic, cut diagonally with skin left on

1 bunch fresh parsley

1 bunch fresh thyme

2 bay leaves

1 tablespoon coarse kosher salt

1 tablespoon whole peppercorns

1 cup dry red wine, preferably cabernet

Preheat oven to 450 degrees. Lightly oil a roasting pan and place bones in pan to roast for 30 minutes, turning once. Rub tomato paste on beef bones, add cut vegetables and roast another 30 minutes. Remove from oven and place into stockpot with water, vegetables and herbs. Deglaze roasting pan with 1 cup of red wine and add to stockpot. Bring to a boil and turn down to a gentle boil for 30 minutes. Turn down to a simmer for 4 to 5 hours, skimming off impurities that rise to the top as needed. Strain all the contents, discard and cool stock. Skim off fat and use immediately or portion into Ziploc bags, filling three-quarters full, and freeze flat. Can be kept in freezer up to 3 months.

BASIC LAMB STOCK

6 pounds meaty lamb bones (chops, shanks, ribs, etc.)

4 tablespoons tomato paste

2 large onions, cut in half diagonally with skin left on

3 large carrots, washed and unpeeled, cut into thirds

2 large celery ribs with leaves, washed and cut into thirds

½ head of garlic, cut diagonally with skin left on

6 quarts (24 cups) warm water

1 bunch fresh parsley

1 bunch fresh thyme

2 bay leaves

1 tablespoon coarse kosher salt

1 tablespoon whole peppercorns

1 cup dry white wine, preferably sauvignon blanc or pinot grigio

Preheat oven to 450 degrees. Lightly oil a roasting pan, place bones in pan and roast for 30 minutes, turning once. Rub tomato paste on lamb bones, add vegetables and roast another 30 minutes. Remove from oven and place into stockpot with water, herbs and spices. Deglaze roasting pan with 1 cup of white wine and add to stockpot. Bring to a boil and turn down to a gentle boil for 30 minutes. Turn down to a simmer for 4 to 5 hours, skimming off impurities that rise to the top as needed. Strain all the contents, discard and cool stock. Skim off fat and use immediately or portion into Ziploc bags, filling three-quarters full, and freeze flat. Can be kept in freezer up to 3 months.

BASIC VEGETABLE STOCK

6 large tomatoes, cored and quartered

3 large onions, cut in half diagonally with skin left on

6 large carrots, washed and unpeeled, cut into thirds

4 large celery ribs with leaves, washed and cut into thirds

½ head of garlic, cut diagonally with skin left on

1 celery root, chopped (optional)

3 tablespoons olive oil

6 quarts (24 cups) warm water

1 bunch fresh parsley (or half parsley/half cilantro)

1 bunch fresh thyme

3 sprigs fresh oregano

1 tablespoon coarse kosher salt

1 tablespoon whole peppercorns

6 ounces dried shiitake mushrooms or 8 ounces halved fresh cremini (optional)

1 bunch scallions with roots, washed and roughly chopped, white and green parts only

1 cup dry white wine, preferably sauvignon blanc or pinot grigio

Preheat oven to 450 degrees. Toss all vegetables except scallions with 3 tablespoons olive oil in a roasting pan and roast for 1 hour, stirring every 15 minutes, careful not to burn garlic. Remove from oven and place into stockpot with water, herbs, spices, mushrooms and scallions. Deglaze roasting pan with 1 cup of white wine and add to stockpot. Bring to a boil and turn down to a gentle boil for 30 minutes. Turn down to a simmer for 4 hours. Strain all the contents, discard and cool stock. Use immediately or portion into Ziploc bags, filling three-quarters full, and freeze flat. Can be kept in freezer up to 3 months.

EASY SUBSTITUTES

With any substitutes, the recipe's end result may not be completely accurate, but these are quick alternatives.

BUTTERMILK

I cup whole or 2% milk,
 less I tablespoon milk
I tablespoon white vinegar or
 lemon juice

Mix together milk, vinegar or lemon juice to make I full cup of liquid and add to recipe as needed.

CONFECTIONER'S (POWDERED) SUGAR

I cup white sugar
I tablespoon cornstarch

Place in a blender and mix until the sugar and cornstarch are of a fine consistency, like confectioner's sugar.

EGG CONVERSION FOR BAKING

I tablespoon vinegar
I tablespoon water
I teaspoon baking powder

Mix together vinegar, water and baking powder, and add liquid to recipe as needed. Conversion equal to I egg.

MEASUREMENT CONVERSIONS

I tablespoon=*3 teaspoons*
I cup=*16 tablespoons or 8 fluid ounces*
I pound=*16 ounces*
I pint=*16 fluid ounces or 2 cups*
I quart=*2 pints or 4 cups*
I gallon=*4 quarts, 8 pints or 16 cups*
I stick (butter)=*½ cup, 8 tablespoons or 4 ounces*
2 sticks (butter)=*I cup, 16 tablespoons, 8 ounces or ½ pound*

BIBLIOGRAPHY

All Trips, Missoula, Montana. "National Bison Range." www.allmissoula.com/nature/national_bison_range.php.

Geraets, Wade T. E-mail on Chinook salmon, 2017.

Goodman, Marla. "Only the Pluckiest Survive: Apple Varieties in Montana, Sidebar: Apple recipes." Montana State University Extension, October 3, 2002. www.montana.edu/news/540/only-the-pluckiest-survive-apple-varieties-in-montana-sidebar-apple-recipes.

Goss, Robert V. "Frank Haynes and the Haynes Photo Shop—1884 to 1967. Excerpt from 'Making Concessions in Yellowstone.'" Geyser Bob's Yellowstone Park Historical Service, 2004. web.archive.org/web/20091027053005/http://www.geocities.com/geysrbob/Stores-Haynes.html.

Gough, R.E. "Growing Minor Stone Fruit in Montana." Montana State University Extension, August 2002. www.msuextension.org/publications/YardandGarden/MT200208AG.pdf.

Kittredge, William, and Annick Smith. *The Last Best Place: A Montana Anthology.* N.p.: Montana Historical Society, 1988.

Meyer, Bill. "Sheep, Lamb, and Goat Inventory, January 1, 2016." United States Department of Agriculture Montana.gov, Official State Website.

Montana Fish Wildlife and Parks. "Antelope." fwp.mt.gov/fishAndWildlife/management/antelope.

———. "Crayfish." fwp.mt.gov/education/angler/fishId/crayfish.html.

———. "Snakes." fwp.mt.gov/recreation/safety/wildlife/snakes.

MontanaKids.com. Agriculture and Business. "Crops." montanakids.com/agriculture_and_business/crops.

————. "The History of Montana's Cattle Industry." montanakids.com/agriculture_and_business/farm_animals/History_of_Cattle.htm.

————. "Wheat." montanakids.com/agriculture_and_business/crops/Wheat.htm.

Murphy, Dan. *Lewis and Clark Voyage of Discovery: The Story Behind the Scenery.* N.p.: KC Publications, Inc., 1977.

National Agricultural Statistics Service, January 9, 2016. www.nass.usda.gov/Statistics_by_State/Montana/Publications/News_Releases/2016/MT_Sheep_and_Goat_Inventory_01292016.pdf.

National Parks Traveler. "Frank Jay Haynes, a Photography Pioneer in Yellowstone National Park." March 5, 2013. www.nationalparkstraveler.org/2013/03/frank-jay-haynes-photography-pioneer-yellowstone-national-park22873.

Picton, Harold D., and Terry N. Lonner. *Montana's Wildlife Legacy: Decimation to Restoration.* N.p.: MediaWorks Publishing, 2008.

Scott, Kim Allen. "Haynes Studio and Haynes Pictures Shops Records, 1878–1932." Archives West, Orbis Cascade Alliance, 2015. archiveswest.orbiscascade.org/ark:/80444/xv84210.

U.S. Fish & Wildlife Service. "About the Refuge." April 24, 2017. www.fws.gov/refuge/National_Bison_Range/about.html.

————. "Bison, American Buffalo (Bison bison)." March 12, 2013. www.fws.gov/refuge/national_bison_range/wildlife_and_habitat/bison.html.

What's Cooking America. "German Chocolate Cake History." whatscookingamerica.net/History/Cakes/GermanChocolateCake.htm.

Zarzyski, Paul. "Another Type of Oyster: Escorting Grammy to the Potluck Rocky Mountain Oyster Feed at Bowman's Corner. For Ethel 'Grammy' Bean." In "The Make-Up of Ice" (1984). *The Last Best Place: A Montana Anthology.* Montana Historical Society, 1988.

INDEX

ABOUT THE AUTHORS

Montana native Chef Barrie Boulds (chefbarrieboulds. com) has more than twenty-eight years of experience in the food industry as a chef and former owner of acclaimed fine dining restaurant Sydney's Mountain Bistro– West Yellowstone. Chef Boulds also continues her private chef and catering business in the Greater Yellowstone area. Her former restaurant has been featured in *Wine Enthusiast* magazine and in various write-ups in the *New York Times* restaurant review, *Fodor's* and *USA Today*, just to name a few, and has served clientele from celebrities to former presidents and their staff. Chef Boulds was born and raised on the Fort Peck Assiniboine and Sioux Reservation, where her interests, talents and passions for the culinary arts developed.

Jean Petersen (jeanpetersen.com) has more than twenty years of experience in professional writing since graduating from Colorado State University. She's been a weekly columnist and freelance writer for *Western Ag Reporter* in Billings, Montana, since 2006. Several of her feature articles can be found in *Distinctly Montana* and *Raised in the West* magazines. Jean is a published author of a nonfiction children's

picture book, *Moose Shoes*, and a member of the Society of Children's Book Writers and Illustrators and Women Writing the West. She has three children's picture books in publication, with her latest to be released in 2018. She has lived in Colorado and Montana for nearly twenty-five years. Her family is active in the opportunities surrounding the great Montana outdoors and agricultural activities, including their small farm.

NOTES

Visit us at
www.historypress.com